IMAGES
of America

THE CALIFORNIA CHANNEL ISLANDS

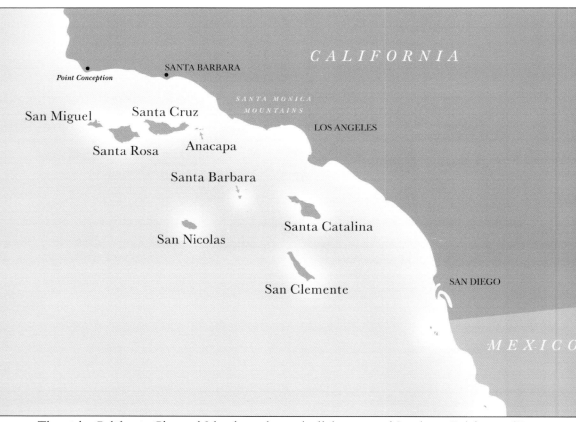

The eight California Channel Islands are located off the coast of Southern California. (Santa Cruz Island Foundation.)

IMAGES
of America

THE CALIFORNIA CHANNEL ISLANDS

Marla Daily
Santa Cruz Island Foundation

ARCADIA
PUBLISHING

Published by Arcadia Publishing
Charleston, South Carolina

Printed in the United States of America

Library of Congress Control Number: 2012931244

For all general information, please contact Arcadia Publishing:
Telephone 843-853-2070
Fax 843-853-0044
E-mail sales@arcadiapublishing.com
For customer service and orders:
Toll-Free 1-888-313-2665

Visit us on the Internet at www.arcadiapublishing.com

To the legacy of Bill Connally (1929–1987), his wife, Lil, and their children, Mark, Kirk, Cherryl, and Brad. By hard work and perseverance, through weather fair and foul, they founded Island Packers in 1968. In recognition of an extraordinary family—the Connallys—this book is for you.

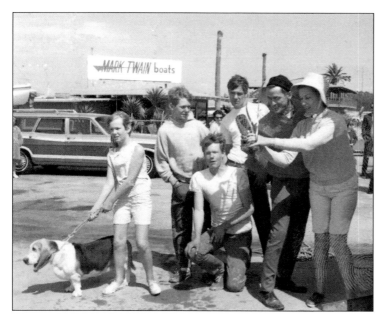

THE CONNALLYS CHRISTEN THEIR FIRST BOAT. Island Packers, Inc., was born on Mothers Day, May 12, 1968 when the vessel, *Island Packer*, was launched at Anchors Way, Ventura Harbor. From left to right are Cherryl Connally, Brad Connally, Kirk Connally (kneeling), Mark Connally, and parents Bill and Lil Connally. (Santa Cruz Island Foundation.)

CONTENTS

ACKNOWLEDGMENTS

This book is made possible by the Santa Cruz Island Foundation (SCIF), established by Carey Stanton (1923–1987) in 1985 to protect and preserve the cultural histories of all eight California Channel Islands. I am indebted to many who so graciously shared their island memories with me before they died: Frankie and Roy Agee, Justy and Marcia Caire, Helene Caire, Vivienne Caire Chiles, Pier and Francis Gherini, Charles Hillinger, Buster Hyder, Phil Orr, Clif Smith, E.K. and Angie Smith, Carey Stanton, and Al and Russ Vail.

Warm thanks are due to many friends who shared their island photographs, artifacts, and family archives: Bill Dewey, Meredith Abbott (San Miguel Island), Brian Andrews (Santa Rosa Island), Gladys Bibb (San Nicolas Island), Wesley Clover (Bowers family), Jay Dusard (Santa Rosa Island), Bill Ehorn (Santa Rosa Island), Michael Glassow (Juana Maria), Llew Goodfield, Seth Hammond (San Miguel Island), Jeannie Hess (San Nicolas Island), David Howell, Nancy Hudson (Linton family), Denton Hyder (Santa Barbara Island), Steve Junak, Fred Kilbride (P.V. Reyes photographs), Jim and Judy Leslie (Juana Maria), Don Mills (Meryl Allen photographs), Betsy Lester Roberti (San Miguel Island), Karen and Eddie Smith (Santa Rosa Island), Wilfred Sturgeon (San Clemente Island), J.B. Summerfield (Blair family, San Clemente Island), Tim Vail and Will Woolley (Santa Rosa Island), Keith Westcott (San Nicolas Island), Robert Wheeler (Santa Cruz Island), and Willie Wood (Anacapa Island).

Acknowledgments are due to the many institutions that provided additional island images: Barry Landua, Anibal Rodriguez, and Dr. David Thomas, American Museum of Natural History (AMNH); Beinecke Rare Book and Manuscript Library, Yale University (BRBML); California Department of Fish & Game (DFG); Debra Kaufman and Mary Morganti, California Historical Society (CHS); Kathleen Correia, California State Library (CSL); Jeannine Pedersen and Gail Fornasiere, Santa Catalina Island Museum (CIM); Ann Huston, Channel Islands National Park (CINP); Huntington Library (HL); Cherryl Connally, Island Packers (IPCO); Charles Johnson, Museum of Ventura County (MVC); Steve Schwartz, Naval Air Warfare Center Weapons Division Command Archives, Point Mugu (NAVAIR); Michael Redmon, Santa Barbara Historical Museum (SBHM); John Johnson, Ray Corbett, and Terri Sheridan, Santa Barbara Museum of Natural History (SBMNH); Geoff and Alison Wrigley Rusack, Gail Hodge, and Gina Long, Santa Catalina Island Company (SCICo); Bill Hendricks, Stuart Robinson, and Jill Thrasher, Sherman Library (SL); Marilyn Kim, Southwest Museum (SWM); Jeff Wheeler, US Lighthouse Society (USLS); and Ellen Guillemette, US Marine Corps Command Museum. Invaluable manuscript preparation was accomplished by the talented Peggy Dahl. Chapter reviews by island cognoscenti Ann Huston, Jeannine Pedersen, Steve Schwartz, Nita Vail, and Andy Yatsko were very helpful.

Thank you to Lawrence Bailard and David Griggs for your valuable input. Most of all, I thank my extraordinary husband, Kirk Connally, for sharing his love of islands with me. *Mil gracias* to all!

INTRODUCTION

There is an intrinsic quality of mystery shared by islands throughout the world. What is on them? What is familiar? What is new and different? These questions naturally come to mind with each new island experience. Each of the eight California Channel Islands has its own heartbeat and its own unique combination of endemic, native, and introduced species—some shared in common with other islands, others not. During the 20th century, all eight islands shared a common history of ranching endeavors. They variously supported sheep and goats, cattle and horses, and pigs and poultry. Santa Rosa Island, site of the last working island ranch, closed its cattle operations in 1998, and deer and elk hunting ceased in 2011, ending a unique era in the islands' shared history.

Today, five of the eight California Channel Islands fall within the boundaries of Channel Islands National Park, created by Congress in 1980: San Miguel, Santa Rosa, Santa Cruz, Anacapa, and Santa Barbara. Public Law 96-99 calls for the protection of "the nationally significant natural, scenic, wildlife, marine, ecological, archaeological, cultural, and scientific values of the Channel Islands in the State of California." The western portion of Santa Cruz Island remains privately owned by The Nature Conservancy as an inholding within the boundaries of the park; only the eastern 6,200 acres are owned by Channel Islands National Park. Although the US Navy still owns San Miguel Island, it is managed by the Department of the Interior under a 1963 memorandum of agreement amended in 1976. Park jurisdiction includes rocks, islets, submerged lands, and water within one nautical mile of each island. Permanent park headquarters are located at 1901 Spinnaker Drive in Ventura, California. Of the three islands not included in Channel Islands National Park, two are active US Navy military bases—San Nicolas and San Clemente—thus, access is restricted. Santa Catalina Island, with its unincorporated resort city of Avalon, is the island visited most often. The majority of the island is privately owned by the Santa Catalina Island Conservancy. Collectively, the eight California Channel Islands total 350 square miles of land off the Southern California coast.

European explorers discovered the California Channel Islands in the 16th century. In 1542, Juan Rodríguez Cabrillo sailed among them with his ships *San Salvador* and *La Victoria*; Sir Francis Drake passed them aboard *Golden Hind* in 1579; and in 1595, Sebastián Rodríguez Cermeño visited several aboard the *San Agustín*. Only one 17th-century explorer left a written record of these islands—Sebastián Vizcaíno, who sailed to the west coast of North America in 1602 with four vessels under orders of King Phillip of Spain; 167 years later, Gaspar de Portolá's expedition of 1769 claimed the islands and all of Alta California for the King of Spain. In 1793, British navigator George Vancouver standardized the names of the eight California Channel Islands on his charts, naming five islands for saints (Rosa, Barbara, Catalina, Nicolas, and Clemente) and one for an archangel (Miguel). Santa Cruz was named Island of the Holy Cross when a priest in Portolá's expedition accidentally left behind a walking staff topped by an iron cross. When it was returned to the ship by an island Native American, the island was dubbed the Island of the Holy Cross. The name Anacapa is thought to be derived from the Chumash word *Eneepah*, meaning "ever changing" or "deception."

In 1821, after Mexico's successful revolt against Spain, the California Channel Islands passed from Spanish to Mexican ownership. The three largest islands were granted by Mexican governors of Alta California to private citizens: Gov. Juan Bautista Alvarado granted the largest, Santa Cruz Island, to Andres Castillero in 1838; Gov. Manuel Micheltorena granted the second largest, Santa Rosa Island, to brothers José Antonio and Carlos Carrillo in 1843; and Gov. Pio Pico granted the third largest, Santa Catalina Island, to Thomas Robbins in 1846. The other five islands remained ungranted. The 1848 Treaty of Guadalupe Hidalgo ended the Mexican-American War, and Mexico ceded California to the United States. California statehood was granted by Pres. James K. Polk on September 9, 1850, and the California Channel Islands became a part of the state of California.

On March 3, 1851, Congress enacted the Land Claims Act, requiring "each and every person claiming lands in California by virtue of any right or title derived by the Mexican government" to file a claim with a three-member board of land commissioners within two years. Titles to the three privately granted islands of Santa Cruz, Santa Rosa, and Santa Catalina were ultimately upheld. Subsequent ownership seldom changed hands, and each private island's history is dominated by just a few ranching families: Santa Cruz Island by the Caires (from 1869 to 1937) and Stantons (from 1937 to 1987); Santa Rosa Island by the Mores (from 1859 to 1901) and Vail & Vickers (from 1901 to 1998); and Santa Catalina Island by James Lick (from 1867 to 1887), the Bannings (from 1891 to 1919), and the Wrigleys (from 1919 to 1975).

The five ungranted Channel Islands—San Clemente, San Nicolas, San Miguel, Anacapa, and Santa Barbara—became US government property with California statehood. They served as transient homes for otter and seal hunters, Chinese and Japanese abalone fishermen, crawfishers, smugglers, miners, and others seeking economic opportunity. As with the three larger, privately owned islands, ranchers also occupied the five smaller government-owned islands, first as squatters claiming possessory rights, then as official government lessees. Although ranching on an island was arduous work, those who undertook the enterprise seldom quit. Ranching was terminated when the government ultimately cancelled its island leases.

Then as now, pleasure-seekers enjoy camping on the islands, walking the beaches, and hiking the hills. Public transportation to Channel Islands National Park (which includes Anacapa, Santa Cruz, Santa Rosa, San Miguel, and Santa Barbara Islands) is available through park concessionaires: Island Packers runs boats to all five islands, while Channel Islands Aviation flies only to Santa Rosa Island. Private boaters may land on all five islands within the park throughout the year. Multiple mainland ports in Southern California offer boat transportation to Santa Catalina Island through Catalina Express. Helicopter service to Santa Catalina Island is available from Island Express from both Long Beach and San Pedro. The two military islands (San Nicolas and San Clemente) remain off-limits into the foreseeable future. Once one has visited one or more of the California Channel Islands, seeing them across the horizon will never be the same.

One

OF CLIFFS AND CAVES
ANACAPA ISLAND

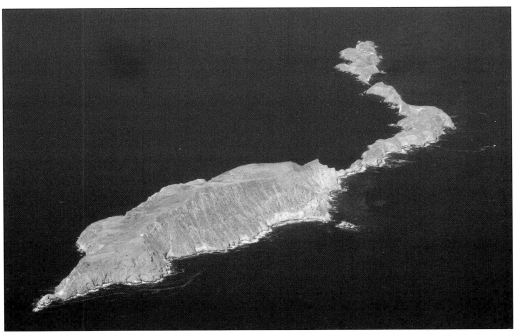

EASTWARD VIEW OF ANACAPA ISLAND. Anacapa Island is almost five miles long but only a quarter-to a half-mile wide. It is composed of three islets, East, Middle, and West, bounded on most sides by sheer cliffs and connected only occasionally at extreme low tides. The three islets total 1.1 square miles and contain approximately 700 acres. Anacapa, which is in Ventura County, is the second smallest island and is only slightly larger than Santa Barbara Island. (SCIF, photograph by Bill Dewey.)

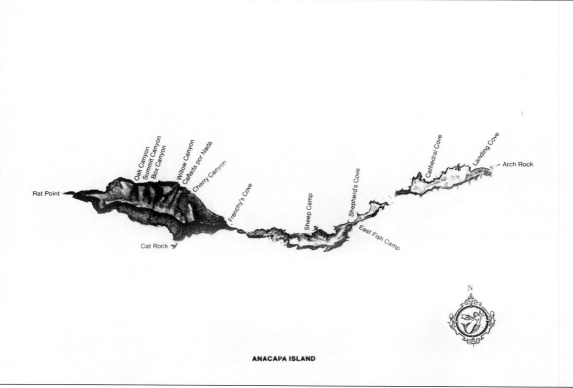

Oak Canyon
Summit Canyon
Box Canyon
Willow Canyon
Cañada por Nada
Cherry Canyon
Cathedral Cove
Landing Cove
Arch Rock
Rat Point
Frenchy's Cove
Sheep Camp
Shepherd's Cove
East Fish Camp
Cat Rock
N

ANACAPA ISLAND

ANACAPA ISLAND. Anacapa Island became federal government property after California became a state in 1850. In 1854, it was set aside for lighthouse purposes, but Uncle Sam took little interest in the island or its occupants until 1902. Several people used Anacapa Island for fishing and ranching purposes, selling what interests they could to others as they left. In 1902, these possessory interests stopped when the government instituted a formal lease agreement policy. In 1938, under Pres. Franklin Roosevelt's Antiquities Act, Anacapa Island became part of Channel Islands National Monument. Channel Islands National Park, which includes Anacapa Island, was created in 1980. The island deer mouse is the island's only native terrestrial mammal. (SCIF.)

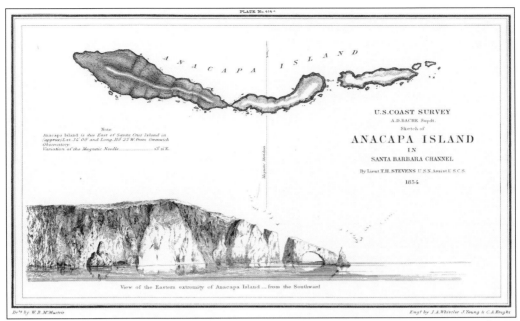

WHISTLER'S ANACAPA ISLAND, 1854. Artist James Abbott McNeill Whistler (1834–1903) was employed by the US Coast Survey as an engraver from November 1854 to February 1855. When tasked with preparing an engraving of Anacapa Island, Whistler added seagulls above Arch Rock and was dismissed. "Surely the birds don't detract from the sketch. Anacapa Island couldn't look as blank as that map did before I added the birds," he famously responded. (SCIF.)

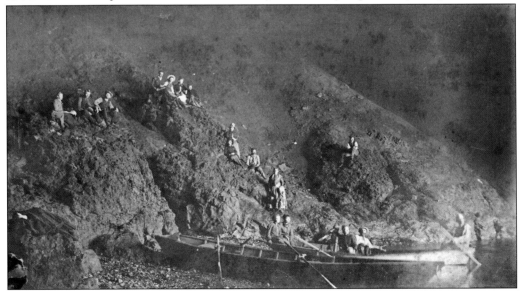

YATES CAVE, WEST ANACAPA ISLAND, 1890. Yates Cave, located west of Frenchy's Cove, is the most spacious and second deepest of the 45 named caves found on Anacapa Island. It was originally described in 1890 by Santa Barbara naturalist Lorenzo Yates (1837–1909). Some time after 1928, the cave's name was changed, by popular use, to Frenchy's Cave. Raymond "Frenchy" LeDreau allegedly used the cave to store bootleg liquor during Prohibition. (SBHM.)

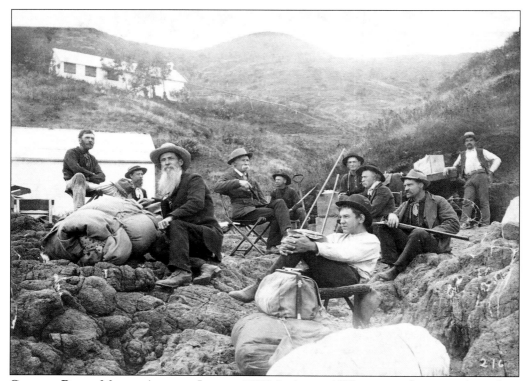

Camping Party, Middle Anacapa Island, 1889. In August 1889, a group of artists and members of the Santa Barbara Natural History Society chartered Ezekiel Elliott's sloop, *Brisk*, for a 10-day cruise to Anacapa Island. The party included photographer Isaac Newton Cook (long beard) and his assistant, Harry Jenkins (far right), naturalist Lorenzo Yates (third from right), and Yates's good friend and noted artist Henry Chapman Ford (center, sitting in a chair). (SBHM.)

Elliott's Sheep Camp, Middle Anacapa Island, c. 1890. Ezekiel Elliott (1833–1912) and his son, Joseph Vincent (1860–1943), bought the rights to Anacapa Island from the Pacific Wool Growing Company in 1882. For 16 years, the Elliotts ran sheep on the island. In 1897, they sold their Anacapa interests to Frenchman Louis LeMesnager for $8,000. In 1902, LeMesnager (1850–1923) became the island's first government lessee (from 1902 to 1907). (SBHM.)

CAMPING ON WEST ANACAPA ISLAND, 1895. Photographer John Calvin Brewster (1841–1909) chronicled life in Ventura County from 1874—a year after its founding—until his death in 1909. The rare images he captured, including this image of a camp on West Anacapa Island in 1895, are preserved in his original glass plate negatives. (SCIF.)

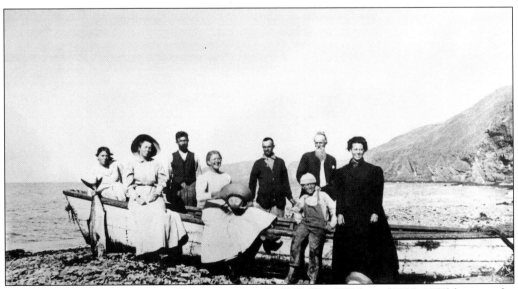

HEMAN BAYFIELD WEBSTER AND FAMILY, C. 1910. In 1907, "Bay" Webster (1866–1950) became the second Anacapa Island lessee (from 1907 to 1917). Webster (long white beard), his wife, Martha (far right), and sons, Morris (seated front) and Harvey, lived on Middle Anacapa Island, raised sheep, and catered to tourists. Webster built five shacks: Capacity, Felicity, Simplicity, Intensity, and Necessity (the outhouse). After Webster, the lease went to Capt. Ira Eaton (from 1917 to 1927), followed by Clarence Fay Chaffee (from 1927 to 1937). (SCIF.)

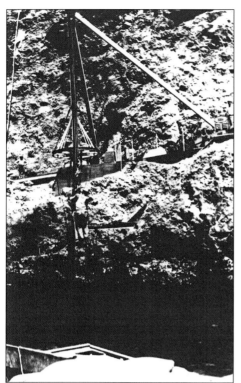

LOWER DERRICK LANDING, EAST ANACAPA ISLAND, 1912. Since the 1853 wreck of the side-wheel steamer *Winfield Scott*, Anacapa was long considered a hazard to navigation. In 1909, Congress approved funds to build a light beacon atop East Anacapa. Island lessee Bay Webster chose the site for lighthouse inspectors, and construction began in 1911. To access the top of the island, a landing derrick was constructed on the sheer cliff in Landing Cove. (CINP.)

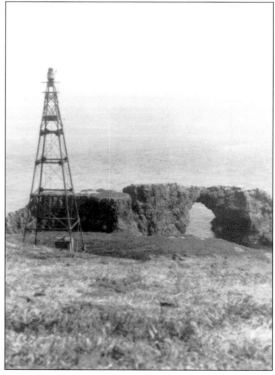

FIRST ANACAPA ISLAND LIGHT, EAST ANACAPA ISLAND, 1912. A 50-foot steel skeleton tower was constructed to hold the automated 530-candlepower acetylene light. After it was turned on in March 1912, the light flashed for one second, with a three-second interval of darkness, followed by one second of light and ten seconds of darkness. The light was serviced every six months by the lighthouse tender *Sequoia* and remained in use until 1930. (CINP.)

ROTH CONSTRUCTION CAMP, EAST ANACAPA ISLAND, 1930. In 1928, the Bureau of Lighthouses allotted funds for construction of a major Anacapa Island lighthouse complex, the last built on the California coast. The contracts included two phases: landing facilities and roads, and buildings. Roth Construction of San Francisco won the first phase bid for $28,950 but defaulted soon thereafter. Carpenter Brothers of Beverly Hills completed the landing derricks and roads. (CINP.)

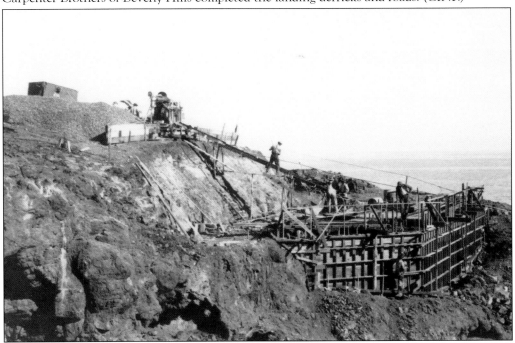

CONSTRUCTION OF THE UPPER DERRICK LANDING, EAST ANACAPA ISLAND, 1931. Concrete was poured for the retaining wall of the upper derrick landing in March 1931. Stairs embedded into the cliff face connected the lower derrick landing, at 15 feet above mean water level, to the upper derrick landing 250 feet above sea level. The lower derrick had a 40-foot, five-ton-capacity boom, and the upper derrick had a 50-foot, four-ton-capacity boom. (CINP.)

FINISHED ROAD LOOKING NORTH, EAST ANACAPA ISLAND, 1931. By May 1931, the dirt roads had been scraped to the lighthouse location, the sites of the four lighthouse keepers' new residences, the water tank house, and other buildings. A 30,000-square-foot cement collecting pad for rainwater was added to the revised phase one contract awarded to the Carpenter Brothers for $36,490. (CINP.)

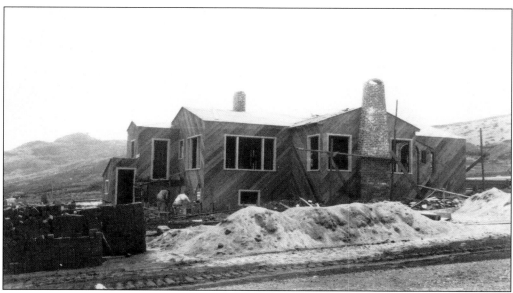

FIRST ASSISTANT KEEPER'S HOUSE, EAST ANACAPA ISLAND, 1931. M.W. Lippman of Los Angeles was awarded the second phase building contract for $74,595, which included construction of a lighthouse, a powerhouse for the generator, an oil house, and a fog signal building. In addition, four lighthouse keepers' dwellings, a tank house, and a general service building were included in the plans. The design called for frame and stucco construction with terra-cotta tile roofs. (CINP.)

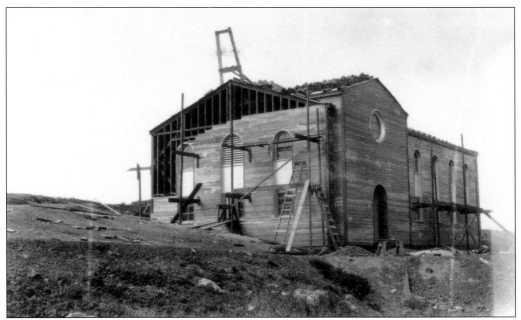

WATER TANK HOUSE, EAST ANACAPA ISLAND, 1931. East Anacapa is a dry island, thus storage was needed for fresh water transported to the island by boat. Rainwater, collected on a 30,000-square-foot concrete pad, was also stored in two tanks of beautifully crafted, joined redwood built by George Wendeler. The tanks were enclosed in a church-like building to protect the redwood from drying out and to keep birds and insects out of the open-top tanks. (CINP.)

LIGHTHOUSE TOWER FOUNDATION, EAST ANACAPA ISLAND, 1931. In August 1931, the new lighthouse tower foundation was placed at the highest point on east Anacapa Island, the site of the original 1912 light, 277 feet above sea level. It was built to support a three-story cylindrical concrete tower almost 50 feet tall, topped by the lighthouse lens. The fog signal building was constructed next to it. (CINP.)

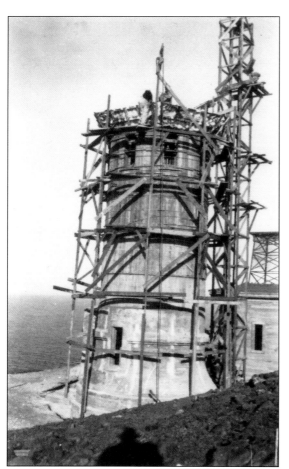

LIGHTHOUSE UNDER CONSTRUCTION, EAST ANACAPA ISLAND, 1931. The lighthouse was nearly completed by Christmas 1931, with 58 circular steps leading up almost 40 feet to an 8.5-foot-diameter lens housing. The light was activated on March 25, 1932, and contained a third-order Fresnel lens equipped with 114 glass prisms and a 2,000-watt, 1,200,000-candlepower light that was visible for 24 miles. (CINP.)

VIEW FROM THE LIGHTHOUSE, EAST ANACAPA ISLAND, C. 1935. The lighthouse complex was home to lighthouse keepers and their families. In 1938, Pres. Franklin D. Roosevelt created Channel Islands National Monument, including both Anacapa and Santa Barbara Islands. In 1939, the Lighthouse Bureau went out of existence, and the Anacapa Island station was transferred to the Coast Guard. The light was turned off during World War II, from 1942 to 1945. (CINP.)

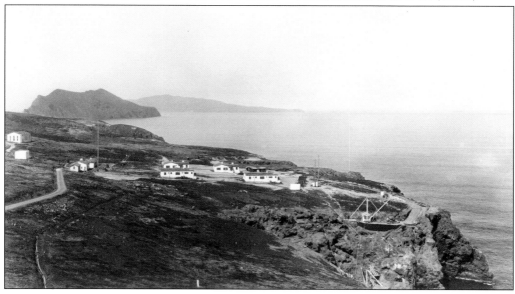

LANDING COVE, EAST ANACAPA ISLAND, 1955.
Getting ashore at East Anacapa Island was no simple task. The Coast Guard's 26-foot, 7,000-pound boat was hooked to a cable in Landing Cove and hoisted out of the water and 25 feet up the perpendicular cliff by the lower derrick boom, then placed on a custom-made cradle on a rock ledge while passengers and crew sat for the unusual ride. (USLS.)

APPROACHING EAST ANACAPA ISLAND FROM OFFSHORE, C. 1985. In 1962, the Coast Guard began converting Anacapa to an unattended operation. In 1967, three of the houses were demolished before Don Robinson (1919–2004), superintendent of Channel Islands National Monument, said the National Park Service (NPS) was interested in the buildings. In 1970, the NPS assumed responsibility, and Anacapa Island became part of Channel Islands National Park in 1980. (SCIF, photograph by Bill Dewey.)

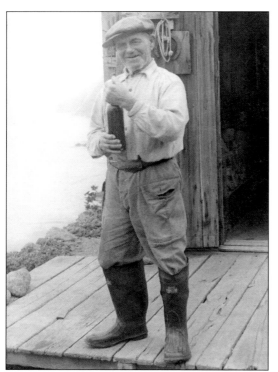

FRENCHY, C. 1940. Legendary fisherman Raymond "Frenchy" LeDreau (1875–1962) moved to West Anacapa Island some time around 1928 and stayed until 1954. He often traded lobster for necessary supplies and liquor. After Anacapa Island became a national monument in 1938, Frenchy acted as an unofficial host for visitors. At the start of World War II, the Navy removed Frenchy, only to have him return. (Don Mills, photograph by Merrill Allyn.)

FRENCHY'S COVE, WEST ANACAPA ISLAND, C. 1940. Frenchy lived alone with his many cats in one of several cabins at the cove that now bears his name. From a tiny window in his cabin, Frenchy could see steamers and potential visitors passing by. A narrow trail led from his shack to the beach where he kept his lobster traps, fishing gear, and mooring device to pull his skiff above high water. (CINP.)

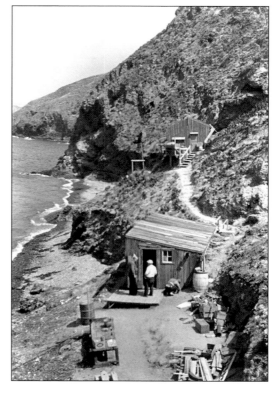

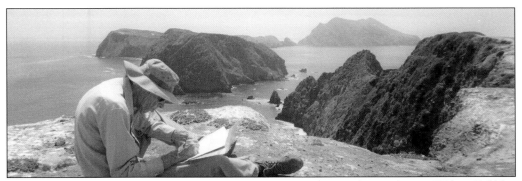

Geologist Tom Dibblee Mapping Anacapa, 1998. Legendary geologist Thomas Wilson Dibblee Jr. (1911–2004) mapped five of the California Channel Islands, beginning with Santa Rosa Island in 1938 for the Richfield Oil Company. He also mapped Anacapa, San Miguel, Santa Cruz, and Santa Barbara Islands. All of Dibblee's island geology maps were published by the Santa Cruz Island Foundation. (SCIF, photograph by William Wood.)

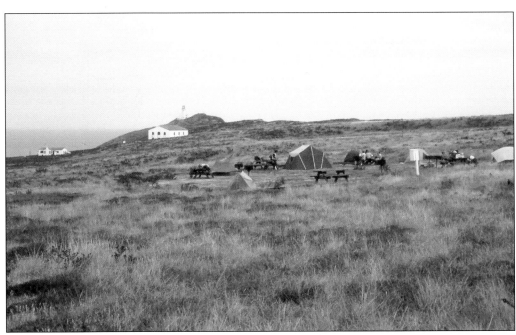

Primitive Campground, East Anacapa Island, 1986. There are seven primitive campsites on East Anacapa Island available to the public by advance reservation, and camping is permitted for up to two weeks. Campsites hold four to six people. There is no fresh water available, and all personal supplies, food, and gear must be transported by the camper. If something is forgotten, one goes without. (SCIF, photograph by Marla Daily.)

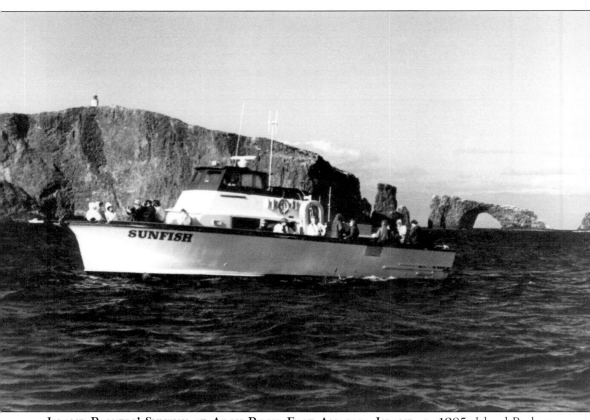

ISLAND PACKERS' *SUNFISH* AT ARCH ROCK, EAST ANACAPA ISLAND, C. 1985. Island Packers, concessionaire to Channel Islands National Park, has been transporting visitors to Anacapa Island since 1968. Most visits are to East Anacapa, 12 miles from the mainland, where visitors must climb 157 steps built into the cliff to get to the top of the island. A well-marked nature trail, roughly in the shape of a figure-eight and one and a half miles long, is laid out on top of the island's mesa. Seabirds and brown pelicans are the most conspicuous island life. Endemic Anacapa Island deer mice, side-blotched and alligator lizards, and Pacific slender salamanders also inhabit the island. Two overlooks atop East Anacapa's steep cliffs (Cathedral Cove and Pinniped Point) provide excellent spots to watch seals and sea lions along the island's rocky shores. The island's historic buildings include the lighthouse, fog signal building, water tank building, three-bedroom ranger residence, generator building combined with living quarters, fuel storage building, and a combination maintenance-storage building that has been partially converted to a visitors' center. Visitors are allowed on Middle Anacapa by permit only. West Anacapa, except Frenchy's Cove, is closed to the public. (SCIF.)

Two

RAINBOW'S END
SANTA CRUZ ISLAND

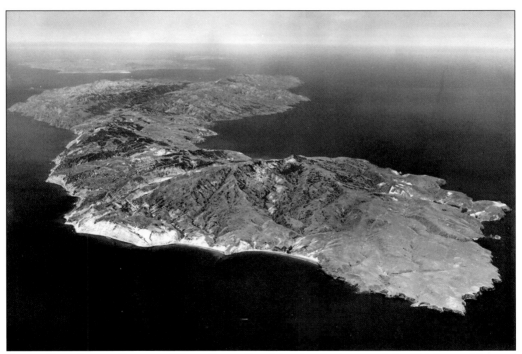

SANTA CRUZ ISLAND LOOKING WEST. Santa Cruz Island is the largest of the California Channel Islands. Its land mass is 96 square miles, or about 62,000 acres, and it is approximately 22 miles long and between two and six miles wide. This island is larger than the District of Columbia and over four times the size of Manhattan! It is in Santa Barbara County and is the only island owned to the water's edge at all times, as stated in its original 1839 grant from Governor Alvarado to Andres Castillero, the island's first private owner (from 1839 to 1857). (SCIF, photograph by Robert Wheeler.)

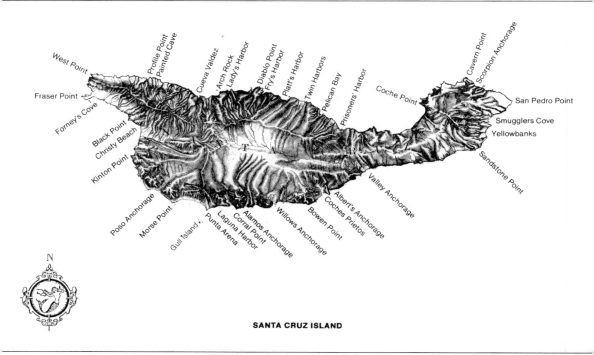

West Point

Fraser Point

Forney's Cove

Profile Point
Painted Cave

Cueva Valdez

Arch Rock
Lady's Harbor

Diablo Point
Fry's Harbor

Platt's Harbor

Twin Harbors

Pelican Bay

Prisoners' Harbor

Coche Point

Cavern Point
Scorpion Anchorage

San Pedro Point

Smugglers Cove

Yellowbanks

Sandstone Point

Valley Anchorage

Albert's Anchorage
Coches Prietos

Bowen Point

Willows Anchorage

Alamos Anchorage

Corral Point
Laguna Harbor
Punta Arena

Gull Island

Morse Point

Poso Anchorage

Black Point
Christy Beach

Kinton Point

N

SANTA CRUZ ISLAND

SANTA CRUZ ISLAND. Santa Cruz Island was the first of three islands granted into private ownership under Mexico's rule of Alta California. In 1839, Andres Castillero received Santa Cruz Island as a gift from Gov. Juan Bautista Alvarado. Transient fishermen and Chinese abalone fishermen camped along the island's shores in the 19th and early 20th centuries until the island's private owners stopped the trespassing. Native terrestrial mammals are limited to the island fox, island spotted skunk, deer mouse, and harvest mouse. (SCIF.)

24

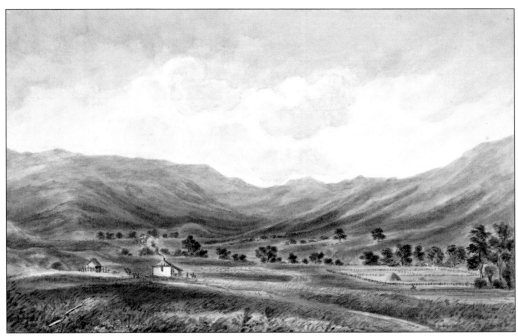

RANCHO AND VALLEY, SANTA CRUZ ISLAND, CALIFORNIA, BY JAMES MADISON ALDEN, 1855. US Coast Survey artist James Madison Alden (1834–1921) painted this, the first known view of Santa Cruz Island. It shows an adobe house with two men—one on horseback and one standing—in front the house, several fenced fields, and some haystacks, thus establishing the existence of both animal husbandry and agricultural practices on the island by 1855. (BRBML.)

PRISONERS' HARBOR, SANTA CRUZ ISLAND, 1869. In 1851, Dr. James Barron Shaw (1814–1902) began paying the taxes on Santa Cruz Island on behalf of island grantee Andres Castillero. As island manager, Shaw placed cattle, horses, and sheep on it; built houses; and cut roads. He continued as manager when the island sold to William E. Barron in 1857 and remained in the position until the island was sold again in 1869. (SCIF.)

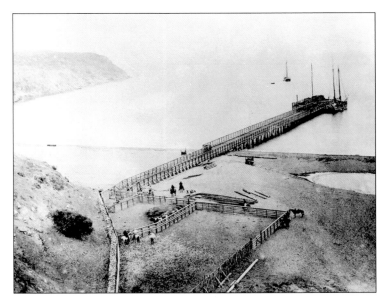

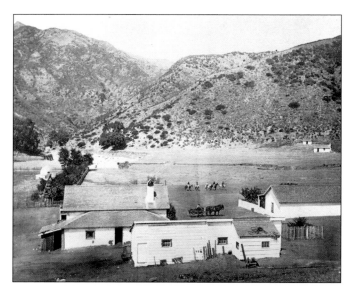

MAIN RANCH, SANTA CRUZ ISLAND, 1869. Ten San Franciscans bought the island from William E. Barron in 1869: Gustav Mahe, Camilo Martin, Alexander Weill, Theodore Lemmen-Meyer, Nicolas Larco, Adrien Gensoul, Giovanni Cerruti, Thomas Gallagher, Pablo Baca, and Justinian Caire. They incorporated the Santa Cruz Island Company on March 29, 1869, with a capital stock of $300,000. In 1873, the company added shareholders J.V. Delavega and Henry Ohlmeyer and increased capital stock to $500,000. (SCIF.)

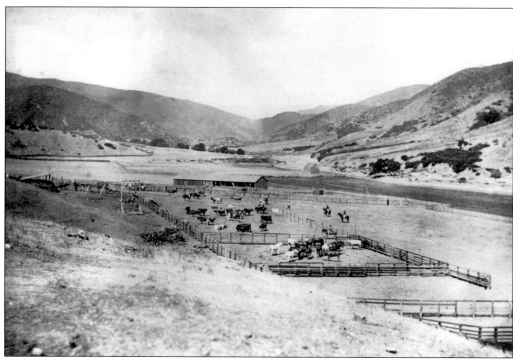

VIEW TO THE WEST, MAIN RANCH, 1869. Santa Cruz Island Company shareholders Larco, Baca, and Gallagher dropped out in 1873; Mahe committed suicide in 1878. In the decade following his initial investment, Justinian Caire acquired all of the company stock from the other investors, becoming sole company shareholder by about 1880. This rare view of the Central Valley was taken before Caire introduced eucalyptus trees to the island. (SCIF.)

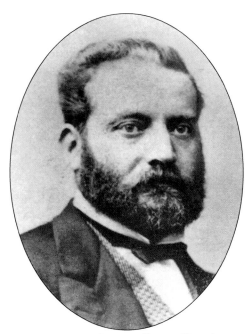 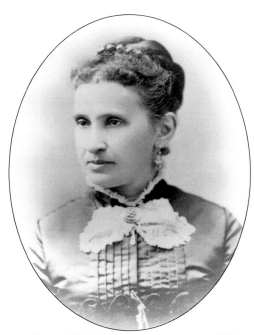

JUSTINIAN AND ALBINA CAIRE. Frenchman Justinian Caire (1827–1897) immigrated in 1851 to San Francisco, where he became a successful merchant. He returned to Genoa, Italy, in 1854 to marry Albina Molfino (1831–1924), and together they returned to San Francisco via Nicaragua and the Isthmus of Tehuantepec. They had nine children, six of whom—two sons and four daughters—survived to adulthood: Delphine (unmarried), Arthur, Amelie, Aglae, Frederic, and Helene (unmarried). (Both, SCIF.)

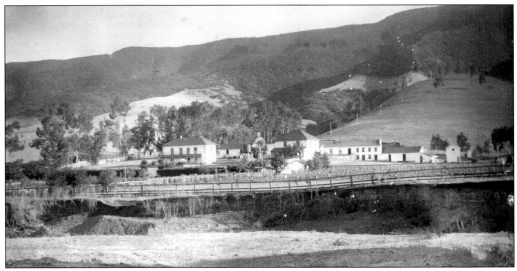

MAIN RANCH, SANTA CRUZ ISLAND, 1880. Justinian Caire made his first island visit in 1880. Over the next 17 years, Caire made vast improvements to the Main Ranch in the island's Central Valley and to nine outlying ranches: Prisoners' Harbor, Christy Ranch, Portezuela, Buena Vista, Rancho Sur, Campo Punta West, Rancho Nuevo, Scorpion, and Smugglers. Island-wide operations were expanded to include viticulture and the raising of sheep and cattle. (SCIF.)

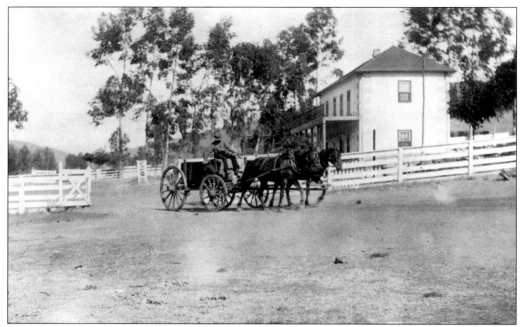

CASA DEL DUEÑO, C. 1890. The Main Ranch family residence of the Caires had a balcony running the entire length of the north-facing second floor. The upstairs rooms had French doors that opened onto the balcony. The spectacular view faced the entrance to Cañada del Puerto and the northern volcanic mountain range. This adobe suffered earthquake damage and was razed and replaced by a 16-room bungalow in 1910. The bungalow burned down in 1950. (SCIF.)

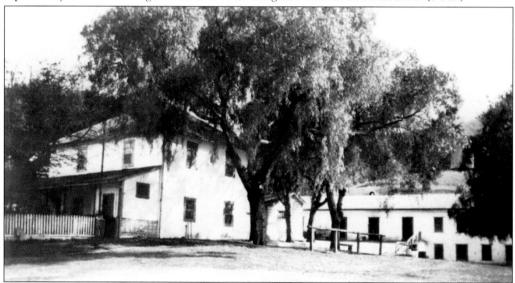

JUSTINIAN HOUSE, MAIN RANCH, SANTA CRUZ ISLAND, 1932. This two-story adobe was built in three stages, the first of which was in place by 1855. Thirty years later, Justinian Caire added two rooms downstairs, turning the adobe into the foursquare house of today. It served as the island superintendent's house. This adobe was subsequent owner Carey Stanton's home for 50 years (from 1937 to 1987); the Stantons later added an interior staircase and two bathrooms. (SCIF.)

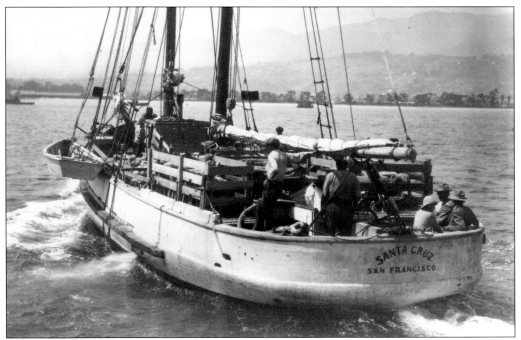

SCHOONER SANTA CRUZ, 1929. Shipwright Matthew Turner designed the 64-foot schooner *Santa Cruz* for Justinian Caire in 1893. *Santa Cruz* served the island for 67 years, transporting supplies, family and friends, employees, and seasonal sheep-shearers and grape-pickers across the channel. The schooner also hauled sheep, wool, cattle, wine, grapes, and other products to mainland markets. On December 7, 1960, *Santa Cruz* parted her mooring at Prisoners' Harbor and was wrecked on the rocks. (SL.)

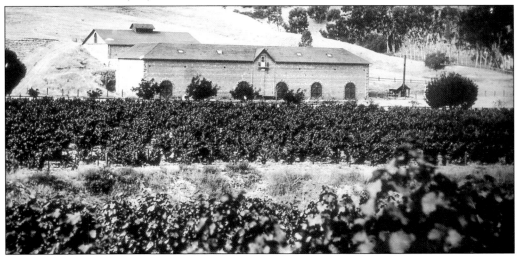

WINERY, SANTA CRUZ ISLAND, 1937. The first grape slips were planted in 1884. The crushing and fermenting cellars, built of island-made brick, were surrounded by 600 acres of grapes. Chablis, Chasselas, Grenache, Muscat, Pinot Noir, Riesling, Sauvignon, and Zinfandel were produced. Wine was shipped to mainland markets in puncheons aboard the company schooner, *Santa Cruz.* (SCIF.)

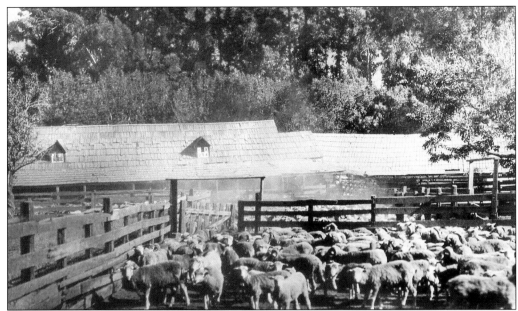

SHEEP AT THE *TRASQUILA*, MAIN RANCH, C. 1940. James Barron Shaw put sheep on Santa Cruz Island in the early 1850s, and by 1856, the sheep consumed in Los Angeles came primarily from Santa Cruz Island. By 1869, there were more than 30,000 sheep; by 1905, more than 40,000; by 1912, up to 55,000. The Caires sold both meat and wool. Dozens of tons of wool were sacked during each shearing season. (SCIF.)

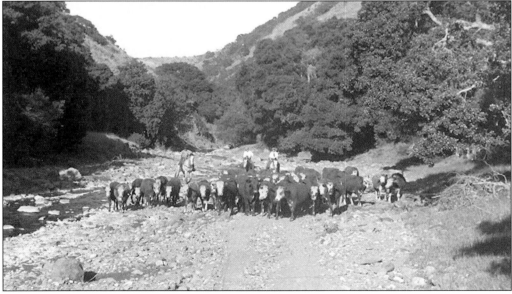

CATTLE BEING HERDED TO THE CORRALS AT PRISONERS' HARBOR, 1937. James Barron Shaw put cattle on Santa Cruz Island in the early 1850s, although sheep dominated the island's industry until the early 1940s. In April 1898, a reported 1,000 head of Santa Cruz Island cattle were sold to mainland markets. In the early 1940s, new island owner Edwin Stanton changed the island from a sheep ranch to a cattle ranch, raising polled Herefords. (SCIF.)

CASA VIEJA, CHRISTY RANCH, 1975. Christy Ranch was built at the western end of the Central Valley, where it meets the ocean. Its adobe-built Casa Vieja dates to James Barron Shaw's island management (from 1851 to 1869). By 1890, this ranch included a two-story bunkhouse across the creek, saddle and harness rooms, blacksmith and carpenter shops, five hay barns, horse and sheep corrals, hog pens, a vegetable garden, corn and hay fields, eucalyptus trees, a well, a windmill, and a water tank. (SCIF.)

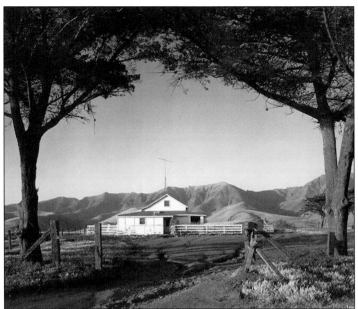

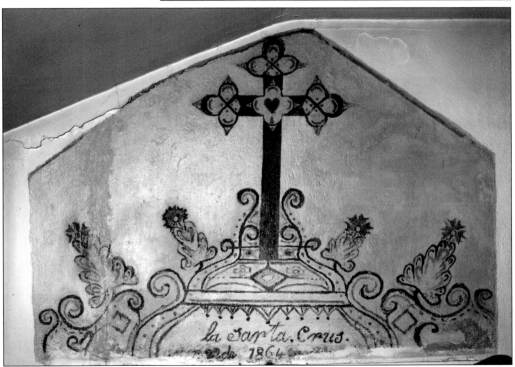

CASA VIEJA MURAL DATED 1864. Although the exact date of construction of the Casa Vieja at Christy Ranch is not known, a mural dating from 1864 is on the wall of one of the two downstairs bedrooms. When the island was partitioned in 1925 because of Caire family litigation, Christy Ranch was included in Tract No. 2—3,367 acres appointed to Frederic Caire, Justinian Caire's fifth child. (SCIF.)

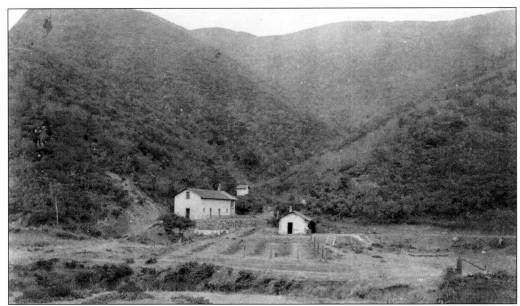

RANCHO PORTEZUELA, C. 1890. From 1885 to 1890, Justinian Caire developed this ranch in the "pass between hills" en route from the Main Ranch to Christy. The Portezuela complex had a two-story adobe house and outhouse, a separate single-story log cabin/adobe with a kitchen/dining room/carpenter shop, a stable, three hay barns, a wood shed, a freshwater well, a hog pen, holding pens, and corrals used for sheep castration. A large vegetable garden and grapevines were cultivated at Portezuela. (SCIF.)

RANCHO SUR, SANTA CRUZ ISLAND, C. 1920. This "south ranch," built to the east of the Main Ranch in 1891, was one of the island's lesser out-ranches. Its simple kitchen/dining room/storeroom was constructed of wood. Its dormitory was moved to the site from the Main Ranch. Rancho Sur fell into disuse prior to the Caires' 1937 sale of the island and was destroyed in 1940. Today, a small citrus orchard marks the site of the ranch yard. (SCIF.)

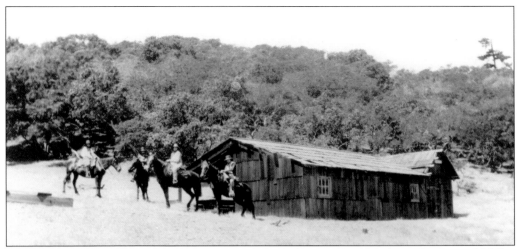

BUENA VISTA, SANTA CRUZ ISLAND, C. 1932. This cabin was located along the Central Valley road, about a half-mile east of the Centinela gate. It was built some time in the 1880s as a place to house workers while the valley road was being built between the Main Ranch and Christy. The building, which could accommodate up to 20 men, was a long wooden shelter with a small kitchen at one end. (SCIF.)

SMUGGLERS RANCH, 2002. Fourteen years after Justinian Caire's death, his two married daughters instigated a suite of lawsuits against their mother and four siblings that divided the family and the island. In 1925, the island was split into seven parcels, one each for Justinian's widow and six children. Tract No. 7, which included Smugglers Ranch, was awarded to Caire's oldest married daughter, Amelie. In 1932, it was acquired by Amelie's oldest daughter, Maria Rossi Gherini, and her attorney husband, Ambrose Gherini. (SCIF, photograph by Bill Dewey.)

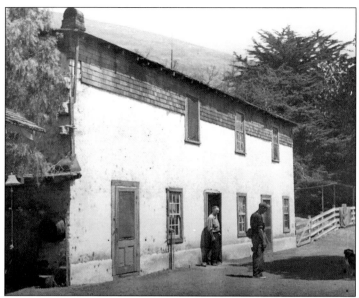

SCORPION RANCH, C. 1940. Tract No. 6, consisting of 3,035.6 acres on the island's east end, included Scorpion Ranch, Cavern Point, Coche Point, and Potato Bay. Like Christy Ranch, Scorpion Ranch was built as one of the island's major outposts. It was assigned to Justinian Caire's other married daughter, Aglae Caire Capuccio (1864–1943). In 1932, this parcel was also acquired by Maria Rossi Gherini and her husband, Ambrose Gherini. (Don Mills, photograph by Merrill Allyn.)

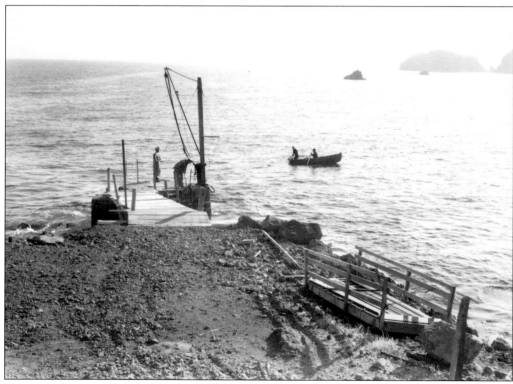

SCORPION HARBOR PIER, 1942. In 1932, the east end of the island became known the Gherini Ranch when Tracts No. 6 and 7 were united by new owners Ambrose Gherini and his wife, Maria Rossi Gherini (Justinian Caire's granddaughter). The first pier was built at Scorpion Harbor in the early 1930s to facilitate shipping sheep. Over the years, a succession of small piers was built, including one made out of a flatbed railroad car. (CINP.)

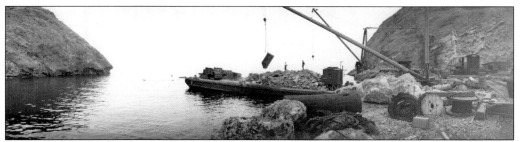

FRY'S HARBOR QUARRY, 1930. Under Caire ownership of Santa Cruz Island, Fry's Harbor was chosen as the quarry site to provide stone for construction of the Santa Barbara breakwater, financed by Maj. Max C. Fleischmann. The New York–based Merritt-Chapman & Scott Corporation quarried rocks that were towed across the channel on large barges. The first pay stone was placed in the breakwater in 1927, the last in 1930, when the quarry facility was abandoned. According to the July 21, 1928, *Santa Barbara Morning Press,* "Donation of another $250,000 by Major Max Fleischmann to the Santa Barbara breakwater construction, announced yesterday, assures the building of at least 600 more feet than is provided for in the present contract. The work now in progress will give the city something over 1100 feet of breakwater. The addition of 600 feet more, with the funds just donated by the Major, will supply a breakwater approximately 1800 feet in length and assure the city of a harbor adequate to protect vessels from southeasters during the winter storms, and thus make it useable all the year round by owners of vessels. The additional work will be built on the east end of the work now in progress, as soon as the present contract is completed. The construction will be by Merritt, Chapman & Scott, the contractors on the present work. The added construction will give the city a harbor costing $650,000, for which the citizens will have paid but $200,000." (SCIF.)

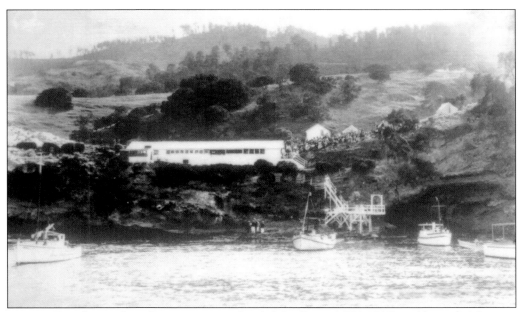

PELICAN BAY, SANTA CRUZ ISLAND, C. 1927. In 1910, Ira Eaton (1876–1938), and his wife, Margaret (1876–1947), moved to Pelican Bay, where they stayed for the next 27 years. In 1913, the Caires gave Eaton exclusive rights to Pelican Bay. The Eatons developed a popular resort that could accommodate up to 80 guests. Film companies made arrangements for large crews, and dozens of silent films were produced on Santa Cruz Island. (SCIF.)

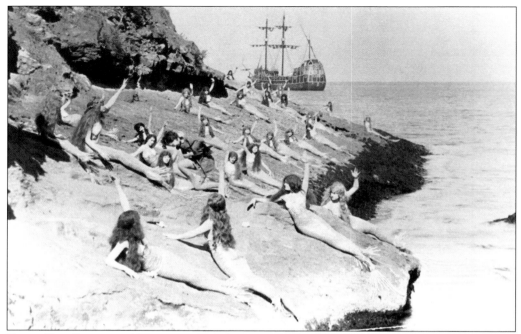

PETER PAN, PRISONERS' HARBOR, 1924. Santa Cruz Island was a stand-in for Never Never Land in the 1925 filming of *Peter Pan*, produced by the Famous Players–Lasky Corporation and directed by Herbert Brenon (1880–1958). Author J.M. Barrie chose Betty Bronson (1906–1971) for the lead role. Margaret Eaton recalled: "She was a very young girl, but for being temperamental she beat anyone who had hit the island!" (SBHM.)

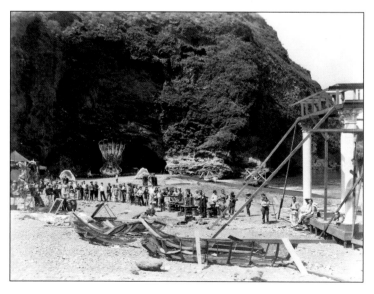

TEMPLE OF VENUS, CUEVA VALDEZ, 1923. The Fox Film Company used several photogenic locations on Santa Cruz Island for filming *Temple of Venus*, including the popular Cueva Valdez on the island's north side and Willows Harbor on the south side. Director Henry Otto (1877–1952) chose Santa Cruz Island over Santa Catalina for its "superior beauty." This silent film starred William Walling (1872–1932) and "1,000 American Beauties." (SCIF.)

STANTONS ARRIVE AT THE PIER ON THEIR NEWLY PURCHASED ISLAND, 1937. Los Angeles businessman Edwin Locksley Stanton (1893–1963) and his wife, Evelyn Carey Stanton (1895–1973), purchased the western nine-tenths of Santa Cruz Island (Tracts No. 1 through 5) from Justinian Caire's heirs in 1937. During the first few years of ownership, Stanton tried to revive the sheep business, but he switched to the cattle business in 1940. Cattle remained the mainstay of island operations until 1987. (SCIF.)

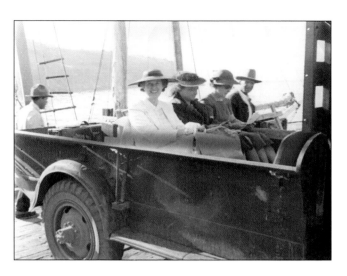

EVELYN AND EDWIN STANTON, C. 1938. The Stantons married in 1916, a year after Edwin graduated from University of California, Berkeley. Their two sons, Edwin Locksley II and Carey, were both teenagers when the Stantons bought the western nine-tenths of Santa Cruz Island (Caire tracts No. 1 through 5) in 1937. Seven years later, Edwin II was killed during World War II in Normandy, France, in 1944, not long after he was married. (SCIF.).

EDWIN LOCKSLEY STANTON, SANTA CRUZ ISLAND, 1937. Stanton served in France in World War I as a first lieutenant in a field artillery division. After the war, he developed a variety of business interests in manufacturing, ranching, and the oil business. Stanton was 44 when he bought his interest in Santa Cruz Island. Five years before his death at age 70, he passed management of the island to his only surviving son, Carey Stanton. (SCIF.)

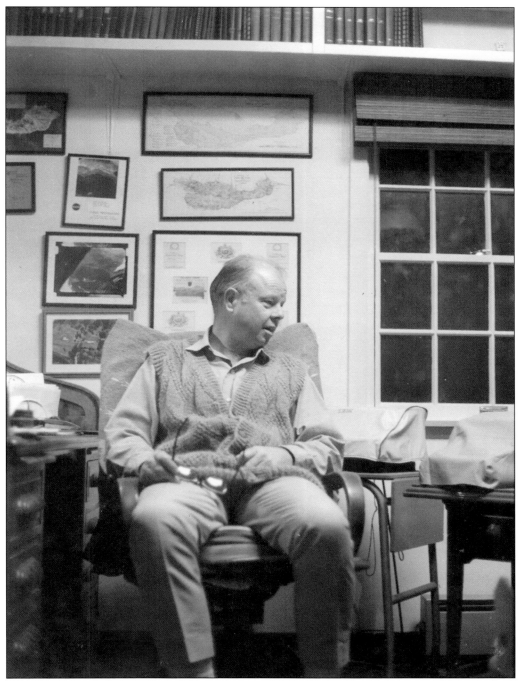

CAREY STANTON IN HIS ISLAND OFFICE, 1972. Carey Stanton (1923–1987), second son of Edwin and Evelyn Stanton, was 14 when his father bought the western nine-tenths of Santa Cruz Island in 1937. Carey graduated from Stanford University School of Medicine in 1947. In 1957, with his father in failing health, Carey left medicine and moved to Santa Cruz Island to live and work in the cattle-ranching business. Carey Stanton never married. (SCIF.)

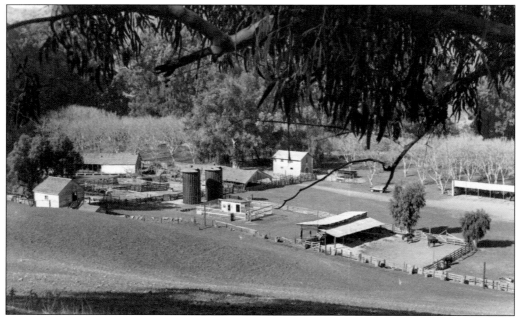

MAIN RANCH, SANTA CRUZ ISLAND, 1946. The Caires had planted an English walnut orchard on three acres to the north of the Main Ranch yard. The nuts were sacked and sold to mainland markets. When the Stantons purchased the island, many of the trees were senescent and were removed to make room for corrals. Two large wood grain silos (center left) had become unstable and were taken down. (SCIF.)

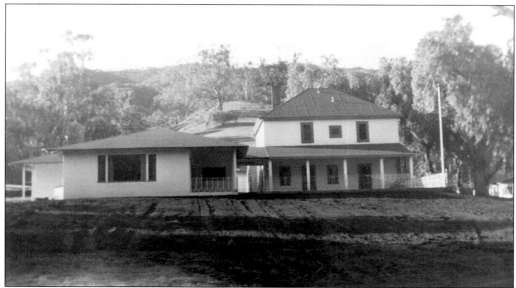

PHOENIX HOUSE, MAIN RANCH, 1952. In June 1950, a fire at the Main Ranch gutted the winery buildings and destroyed the large bungalow built by the Caires in 1915. Edwin Stanton hired Los Angeles architect H. Roy Kelley to design a new, single-story ranch house with a large formal living room, fireplace, wet bar, and two bedrooms with separate baths. The Phoenix House (at left) was connected to the east side of the historic Justinian House adobe by a porch. (SCIF.)

RANCHO DEL NORTE, SANTA CRUZ ISLAND, 1996. This is the only new ranch developed by the Stantons during their 50 years of island ownership (from 1937 to 1987). It was built in 1951 to act as the hub for cattle activities on the east side of the island. Designed by H. Roy Kelley, the rectangular wooden building has two bedrooms, a kitchen/dining/living room, a bathroom, and a storeroom. It sits atop a small hill surrounded by cattle pastures and corrals. (SCIF, photograph by Marla Daily.)

HENRY COWIE DUFFIELD, 1977. In 1960, Edwin Stanton hired Henry Duffield (1921–1986) as cattle manager. Duffield had ranched in Colorado, Cuba, and Mexico, where he was paralyzed by polio from the waist down at age 38. For 26 years, Duffield was the cowboy in the red Jeep with hand controls, a flask of Ancient Age Bourbon and dogs at his side. He died on the island in 1986 and is buried on the island at the La Capilla del Rosario chapel. (SCIF.)

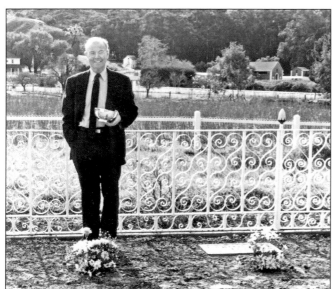

CAREY STANTON STANDING ON HIS OWN GRAVE, 1983. Stanton was a pathologist by education, a historian by avocation, a collector by nature, and a "stickler for detail" by his father's description. His passion for collecting Channel Islands material led to his establishment of the nonprofit Santa Cruz Island Foundation in 1985. On December 8, 1987, at the age of 64, Carey Stanton died at his island home. (SCIF, photograph by Marla Daily.)

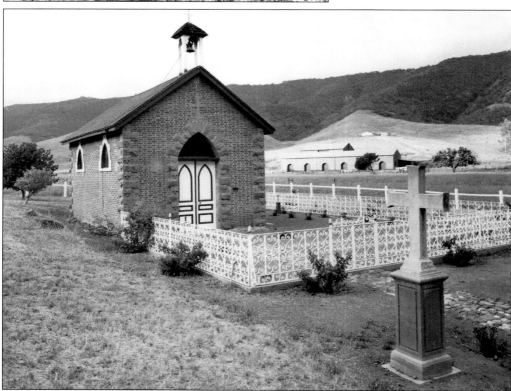

LA CAPILLA DEL ROSARIO, SANTA CRUZ ISLAND, 1991. Rectangular in shape and roughly 27 by 18 feet in size, this chapel was built under the direction of Justinian Caire and completed in 1891. The building is made of island-fired brick with carved stone quoins decorating the corners. Chapel capacity is about 25 or 30. Immediately surrounding the building is a small cemetery where 14 island workers, owners, and family members are buried. (SCIF, photograph by Bill Dewey.)

Three

GRASSLANDS IN THE WIND
SANTA ROSA ISLAND

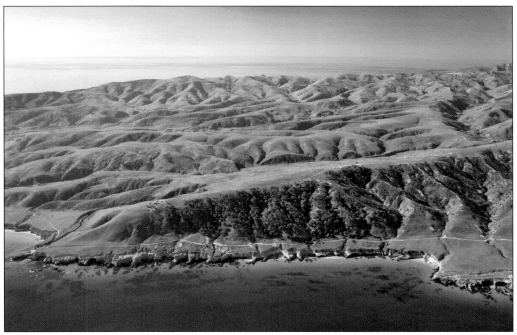

SANTA ROSA ISLAND LOOKING SOUTH, 2009. At 84 square miles, Santa Rosa Island is the second largest of the eight California Channel Islands. It is approximately 15 miles long by 10 miles wide and is located in Santa Barbara County. Santa Rosa Island is 26.5 miles from the nearest mainland, three miles east of San Miguel Island, and six miles west of Santa Cruz Island. From Santa Barbara Harbor, it is 30 nautical miles to Bechers Bay. Vail Peak, at 1,589 feet in elevation, is the highest point on the island. (SCIF, photograph by Bill Dewey.)

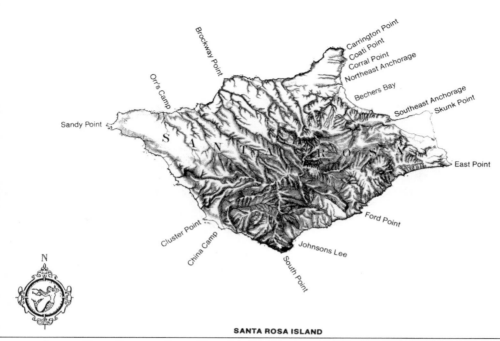

SANTA ROSA ISLAND

Santa Rosa Island. Santa Rosa Island was the second of three islands granted into private ownership under Mexico's rule of Alta California. In 1843, brothers José Antonio and Carlos Carrillo received Santa Rosa Island as a gift from Gov. Manuel Micheltorena. The island was used for ranching from the mid-19th century until 1998. Native terrestrial mammals are limited to the island fox, island spotted skunk, and island deer mouse. (SCIF.)

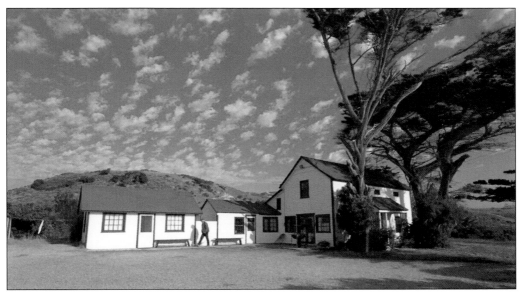

The Carrillo Era, Santa Rosa Island (from 1843 to 1858). In 1843, Governor Micheltorena granted Santa Rosa Island to José Antonio and Carlos Carrillo. They assigned their rights to Carlos Carrillo's daughters, Manuela and Francisca, who were married respectively to Americans John Jones and Alpheus Thompson. The brothers-in-law stocked the island with cattle, sheep, and horses, funded by Jones and managed by Thompson. The partnership ended in court, with Jones prevailing. The island's first house was built in the Carrillo era. (SCIF, photograph by Bill Dewey.)

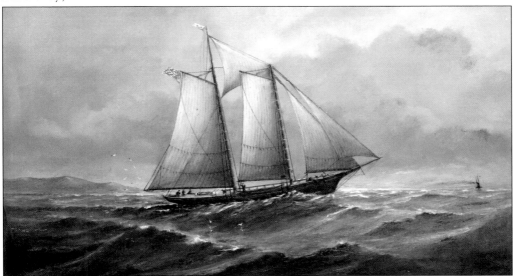

The More Era, Santa Rosa Island (from 1859 to 1901). In 1859, brothers Alexander (1828–1893) and Henry More (1830–1881) bought the Jones/Thompson island interests. Henry More died in 1881, leaving Alexander More as sole owner. Alexander More never married. During the More era, the 61-foot schooner *Santa Rosa* (1879–1899) served the island. Accomplished maritime artist and master of the schooner Frank Wildes Thompson (1838–1908) painted *Sailing from Santa Rosa Island Loaded with Sheep* in 1896. (SCIF.)

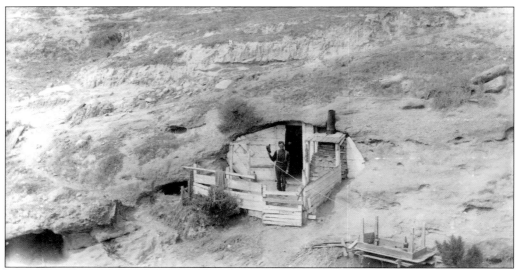

SANTIAGO'S CAVE, 1908. Mexican vaquero Felipe Santiago Quintero was born in 1831. From at least 1864 through 1908, he lived in a cave near the ranch. "Santiago's Cave is a natural hole in the rock, with the front boarded up and fixed with a door. He has a stove and plenty of good furniture, so that he is absolutely comfortable. He has lived alone in his cave for over 30 years" (*San Francisco Call*, June 13, 1897). (SCIF, photograph by P.V. Reyes.)

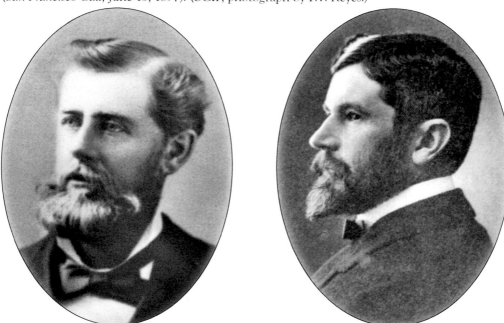

VAIL & VICKERS CO., SANTA ROSA ISLAND (FROM 1901 TO 1986). Arizona ranching partners Walter Lennox Vail (1852–1906), left, and John Van Vickers (1850–1912), right, began purchasing fractional undivided interests in Santa Rosa Island from the heirs of Alexander More in 1901. Within 17 months, the Vail & Vickers Co. owned 21/24ths interest in the island. The remaining 3/24ths interest was purchased by Vail & Vickers Co. two decades later, in 1922. Vail & Vickers immediately changed island ranching operations from sheep to cattle. (SCIF.)

BROTHERS ED AND NATHAN RUSSELL "N.R." VAIL, 1940. Walter Vail died in 1906; J.V. Vickers died in 1912. Vail's oldest son, N.R. Vail (right), assumed island management for the next 37 years (from 1906 to 1943). After his untimely death from a heart attack in 1943, his youngest brother, Ed (left), took over island affairs on behalf of the Vail & Vickers Co. partnership. "Uncle Ed" Vail managed the island until his death in 1961. (SCIF.)

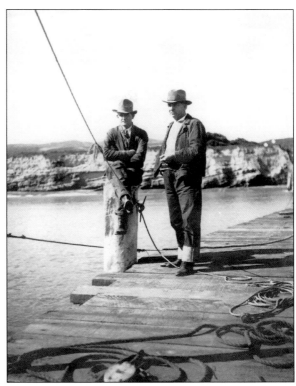

VAQUERO, 1920s. The 130-foot motor vessel *Vaquero* was built for Vail & Vickers by William Muller in 1913 to transport cattle, personnel, and supplies to the island. *Vaquero's* first master was Capt. August Johnson. *Vaquero* served Santa Rosa and neighboring islands for three decades, until the federal government took her under the War Powers Act for service in World War II. *Vaquero* went to the South Pacific and never returned. (SCIF.)

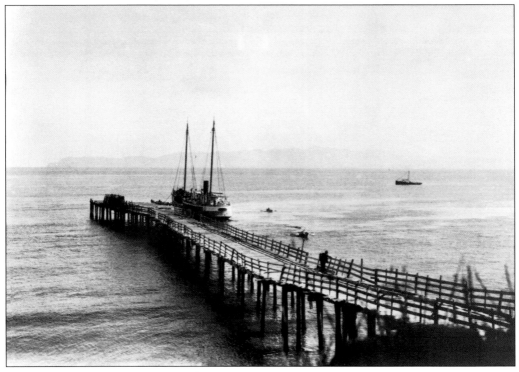

Smith Family, Santa Rosa Island, 1922. Charles Wesley "Smitty" Smith (1869–1954) was foreman on Santa Rosa Island for 33 years (from 1914 to 1947). Ed Vail said: "Smitty never knew how long a day was, and he didn't care. If you followed him, you did a day's work. I never knew any other man with such endurance and strength." All three Smith children were island-schooled. Pictured here are, from left to right, Lon Maynard, Refugia "Cuca" Smith (Smitty's wife), E.K. (Smitty's son), Smitty, and Charlie (Smitty's son). (SCIF.)

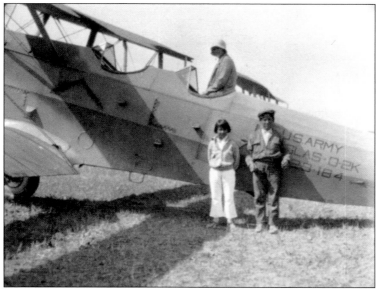

One of the First Santa Rosa Island Flights, 1928. Maude Hunt sits in the plane, while Frances Smith (left) and her brother, E.K. Smith, stand next to it. Maude Hunt was the wife of Hayden Hunt (1894–1971), a Santa Rosa Island cowboy hired under C.W. Smith. Known as "one hell of a bronc rider," Hayden Hunt served as island foreman from 1947 to 1950. (SCIF.)

STANDARD OIL RIG, SANTA ROSA ISLAND, 1932. The search for oil on Santa Rosa Island spanned 43 years (from 1932 to 1975) and included efforts by several companies, four of which actually drilled: Standard Oil Company (from 1932 to 1933), Signal-Honolulu-Macco (from 1948 to 1949), J.R. Pemberton (from 1949 to 1950), and Mobil Oil Corporation (from 1971 to 1975). The oil companies built new island roads, and despite repeated drillings in a variety of locations, no significant oil was ever found. (SCIF.)

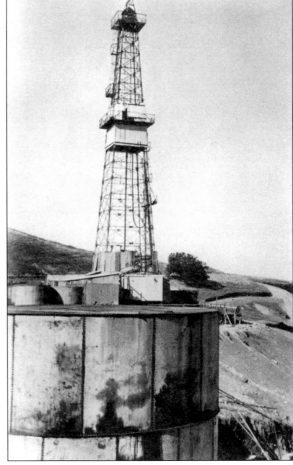

CHINA CAMP, SANTA ROSA ISLAND. Located on the south side of the island, this remote outpost, almost a day's horseback ride from the main ranch, was built in the late 1930s as a shelter for cowboys working cattle in the area. The original three-room wooden house had a kitchen and two bunk rooms. A few years later, a large room was added to the east side of the house. (SCIF.)

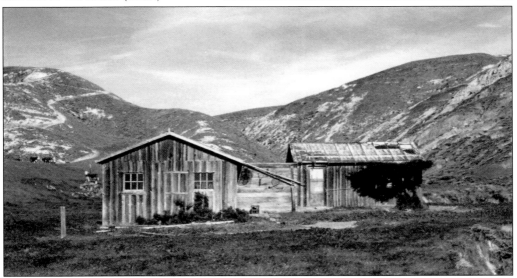

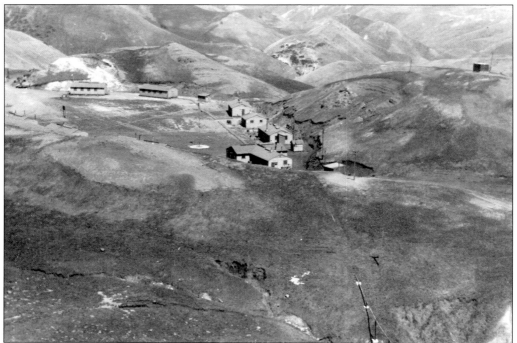

WORLD WAR II ARMY CAMP, SANTA ROSA ISLAND. During World War II, an Army camp was built several miles inland from the main ranch. After the war, J.R. Pemberton's oil exploration crew used the facility, and the site is now called Scott's Camp (after drilling contractor Louis Scott). After the camp was ultimately abandoned, several of the buildings were moved by Vail & Vickers for reuse elsewhere. Today, the star-shaped flagpole foundation remains. (CINP).

BARGING CATTLE FROM SANTA ROSA ISLAND, 1943. After the Vail & Vickers cattle boat, *Vaquero*, was taken for service in World War II, cattle were sent by barge to the mainland. Animals were forced off the barge to swim ashore at the Taylor Ranch in Ventura. The schooner *Santa Cruz*, owned by the Stanton family from neighboring Santa Cruz Island, was made available for shipping Santa Rosa Island cattle to the mainland after the war. (SCIF.)

ORR'S CAMP, SANTA ROSA ISLAND. Phil Orr (1903–1991), curator of paleontology and anthropology at the Santa Barbara Museum of Natural History, began working on Santa Rosa Island in the field season of 1947. For the next 20 years, Orr (pictured above) conducted archaeological, paleontological, and geological field work from his island camp west of Skull Gulch. In 1959 or 1960, Orr discovered the 13,000-year-old remains of Arlington Springs Man, potentially the oldest known human remains in North America. (CINP.)

JOHNSONS LEE, SANTA ROSA ISLAND, c. 1956. From 1951 to 1963, the US government leased about 10 acres from Vail & Vickers for an Air Force air control and warning station during the Cold War. The large military development was manned until 1963 with up to 300 personnel. It was serviced by the US Navy out of Port Hueneme Naval Base using 85-foot crash boats. The facility was abandoned in 1965. (SCIF.)

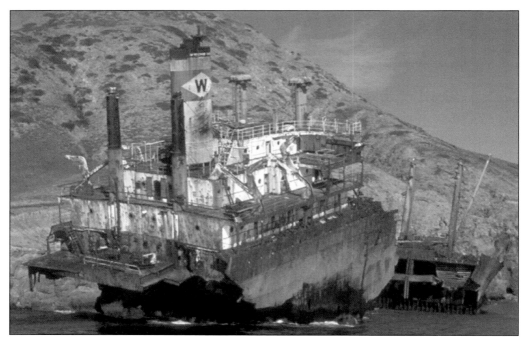

CHICKASAW AGROUND ON SANTA ROSA ISLAND. On February 7, 1962, the 439-foot freighter *Chickasaw* ran aground in a dense fog between Cluster Point and South Point on the south side of Santa Rosa Island as it was traveling from Yokohama, Japan, to Wilmington, California. *Chickasaw* carried a crew of 46, plus four elderly tourists and a large cargo of toys, plywood, dishes, and optical supplies. All of the people on board were rescued, the *Chickasaw* was officially abandoned, and the wreck was left to disintegrate. (CINP.)

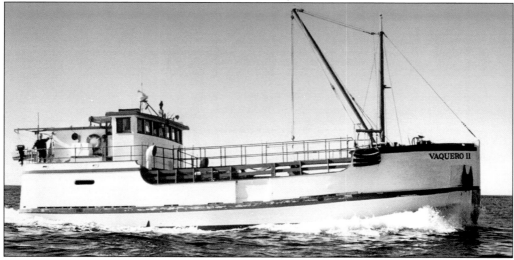

VAQUERO II (1958–1998+). In 1958, Lindwall Boat Works built the 65-foot *Vaquero II* for Vail & Vickers; it was paid for by the US government as a replacement for the vessel taken for use in World War II. *Vaquero II* served Santa Rosa Island for 41 years, until Vail & Vickers closed its island cattle operations. The *Vaquero II* was also used by neighboring Santa Cruz Island after the 1960 sinking of the schooner *Santa Cruz*. (SCIF.)

RUSS VAIL, SANTA ROSA ISLAND, 1995. Russ (1921–2005) and Al Vail (1921–2000), sons of N.R. Vail, were fraternal twins. While Al was the cowboy brother, Russ was bookkeeper for Vail & Vickers. After college at Stanford, Russ graduated from the US Merchant Marine Academy at Kings Point, New York, in 1943. He served in the Merchant Marines in Africa, the South Pacific, and South America before beginning his lifelong career with Vail & Vickers. (SCIF, photograph by Bill Dewey.)

AL VAIL, SANTA ROSA ISLAND. When Ed Vail died in 1961, ranching operations were taken over by his nephew, Al Vail, son of N.R. Vail and grandson of Walter Vail. Al Vail worked on Santa Rosa Island most of his life. As he said: "I grew up cowboying. I can't remember when I started. It was just something I always did." (SCIF, photograph by Bill Ehorn.)

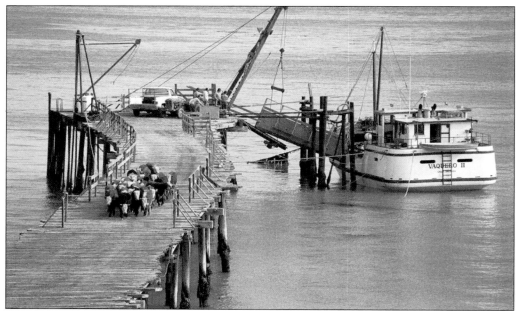

Vaquero II Delivering Young Cattle to Santa Rosa Island. Calves were purchased each fall and taken to the island to hopefully coincide with winter rains and the growth of new green grass. In spring, fattened cattle from the previous year and a half were shipped to the mainland. Between roundup and shipping cycles, fences and roads were repaired, horses were broken, and hay was cut. July was vacation month for the vaqueros. (SCIF.)

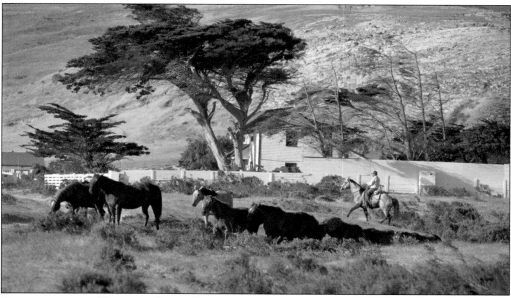

Bringing in the Remuda, Santa Rosa Island, 1998. Vail & Vickers raised its own horses on the island, always carefully choosing breeding stallions. Each island cowboy was responsible for his own string of horses—raising them, breaking them, and shoeing them during roundup season. Vaqueros caught the horses they rode each day to gather cattle. (SCIF, photograph by Bill Dewey.)

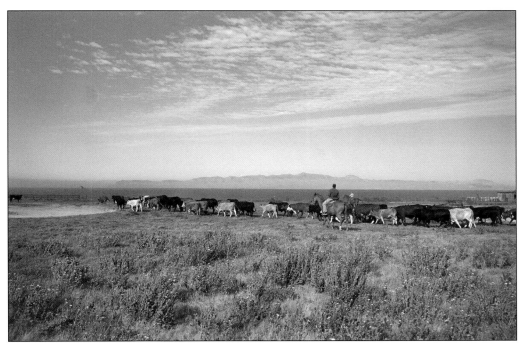

FALL INVENTORY, SANTA ROSA ISLAND, 1998. Each fall, around Labor Day, the island's cattle were brought in from the various pastures to be inventoried and vaccinated. Heavy cattle were sorted and shipped. Cattle had to be gathered from pastures across the island: Old Ranch, Pocket Field, La Jolla, The Wreck, Sierra Pablo, Las Cruces, China Camp, Lepe, Arlington, Lobo, Water Canyon, Windmill, Green Canyon, Soledad, Twin Peaks, and others. (SCIF, photograph by Bill Dewey.)

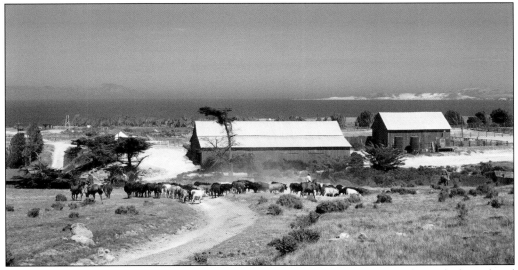

SPRING ROUNDUP, SANTA ROSA ISLAND, 1998. Spring roundup began near the end of April and took up to three months as cattle were gathered, sorted, and weighed before being shipped. Spring roundup and shipping was done by July 4—the cut-off date after which the cattle drop in weight; with work finished, the vaqueros then took a four- to six-week vacation. (SCIF, photograph by Bill Dewey.)

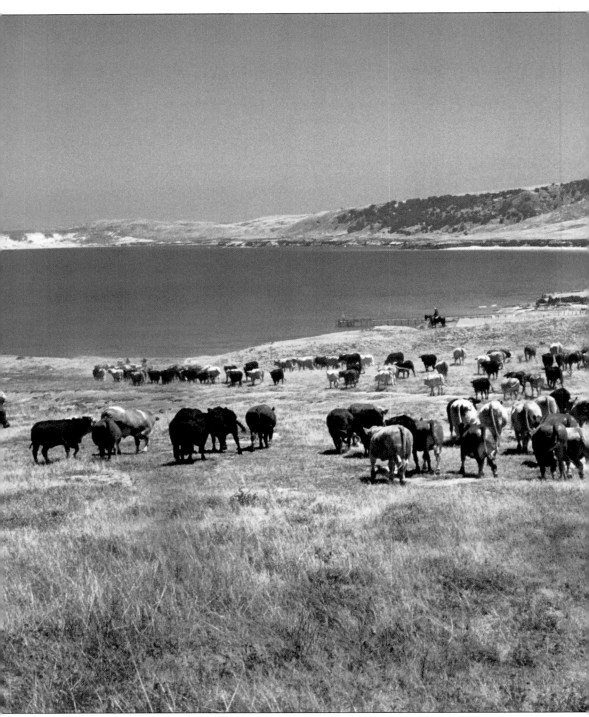

THE GATHER AT CARRINGTON POINT, SANTA ROSA ISLAND, 1998. After ranching ceased on Santa Cruz Island in 1987, Santa Rosa Island became the last island in the United States to gather and ship cattle from an island to the mainland. Offshore ranching logistics necessitated

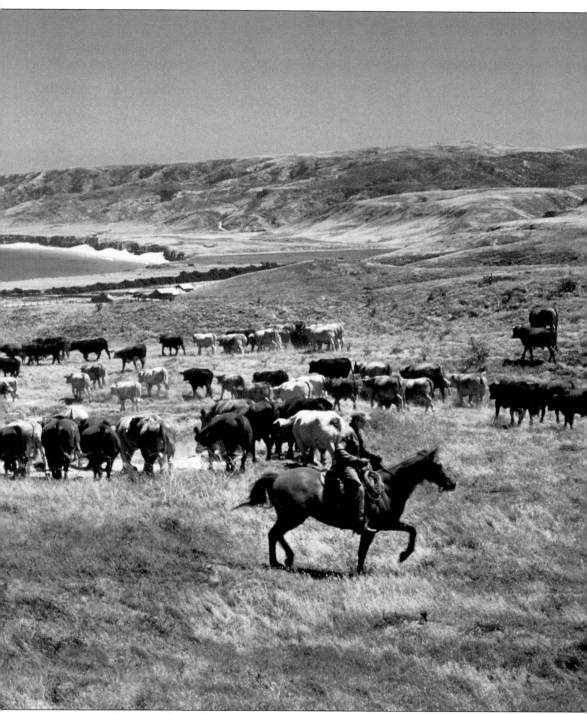

maintenance of a pier and a cattle boat. Vail & Vickers shipped 3.5 million pounds of beef each year. (SCIF, photograph by Jay Dusard.)

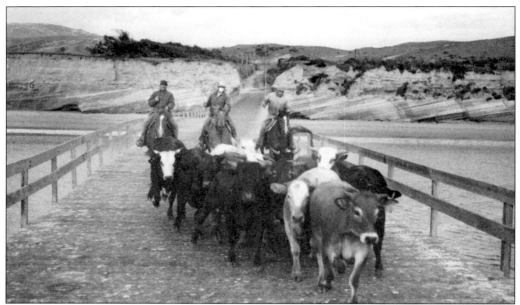

Shipping, Santa Rosa Island, 1998. Shipping began before dawn; the *Vaquero II* was secured against the pier to await her load. Small groups of cattle were brought to the scale, weighed and recorded, and moved through the corrals and gates onto the pier. With the cattle chute lowered to the deck of the boat and the sun rising in the east, cattle were prodded down the chute into the deck's side-by-side pens. (SCIF, photograph by Bill Dewey.)

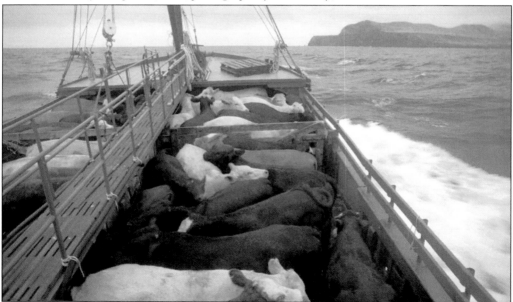

Vaquero II Passing the West End of Santa Cruz Island, 1998. The rich ranching heritage of Santa Rosa Island came to an end in 1998 after conflicts with environmentalists and the National Park Service led to two years of litigation against Vail & Vickers and a mediated settlement that included closure of the island's ranching operations. Family rights of use and occupancy came to an end on December 31, 2011. (SCIF, photograph by Jay Dusard.)

Four

GRAVEYARD OF SHIPS
SAN MIGUEL ISLAND

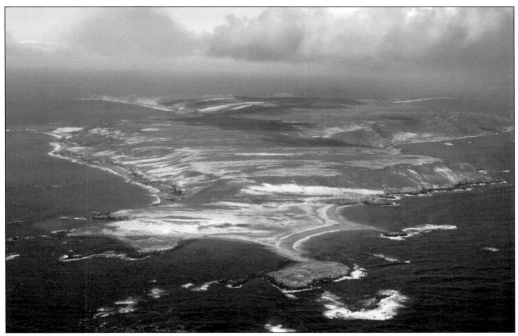

SAN MIGUEL ISLAND LOOKING EAST. At 14 square miles in size, San Miguel Island is the third smallest of the eight California Channel Islands and westernmost of the four Northern Channel Islands. Including Prince Island, at the entrance to Cuyler's Harbor, San Miguel Island is just under 10,000 acres. Green Mountain, at 831 feet in elevation, is the island's highest point. It is 26 miles from the nearest mainland and three miles west of its nearest neighbor, Santa Rosa Island. San Miguel Island is in Santa Barbara County. (SCIF.)

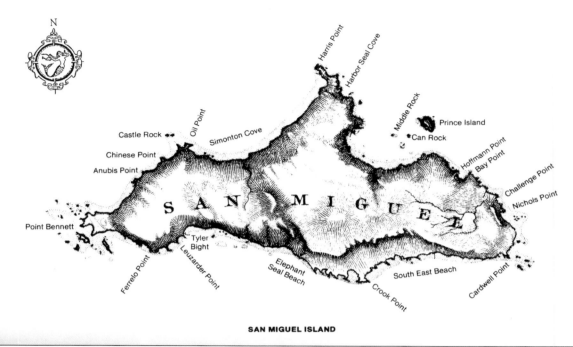

SAN MIGUEL ISLAND

SAN MIGUEL ISLAND. San Miguel Island became US government property when California became a state in 1850. With its large population of pinnipeds, the island served as a transient home for otter and seal hunters throughout the 19th century and into the 20th century. Ranchers moved onto the island in the 1850s, introducing livestock. From 1911 to 1948, the federal government leased San Miguel Island to private sheep-ranching interests. In 2012, American author T.C. Boyle wrote *San Miguel*, a fictional account of the Waters and Lester families who lived on San Miguel Island. Native terrestrial mammals are limited to the island fox and island deer mouse. (SCIF.)

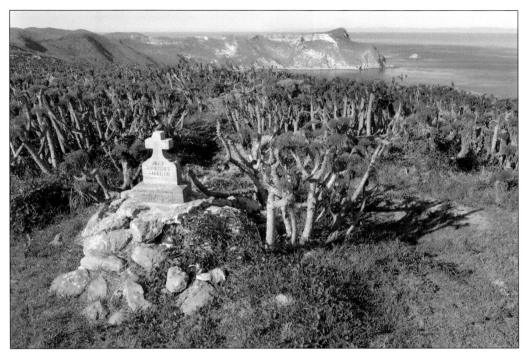

CABRILLO MONUMENT, SAN MIGUEL ISLAND. Juan Rodríguez Cabrillo is credited as being the first European discoverer of California. Controversy surrounds both Cabrillo's birth nation (Spain or Portugal) and his place of death on January 3, 1543 (San Miguel Island, Santa Rosa Island, or elsewhere). In 1937, the Cabrillo Civic Clubs of California placed a white marble monument on San Miguel Island in his honor. (SCIF, photograph by Bill Dewey.)

THE NIDEVER YEARS, SAN MIGUEL ISLAND (FROM 1851 TO 1870). The first man to take the challenge of ranching on San Miguel Island was Samuel Bruce. Although Bruce had neither title nor lease to the island, he ran sheep and cattle and maintained horses there. Bruce sold his island interests to Capt. George Nidever in 1851. Nidever built an adobe in a small canyon 400 feet above Cuyler's Harbor and used the island for nearly two decades. (CINP.)

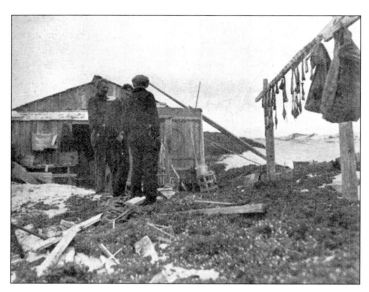

SEALING SHACK AND SEALERS AT POINT BENNETT, SAN MIGUEL ISLAND, JUNE 1927. Six species of seals and sea lions inhabit San Miguel Island: northern fur seal, California sea lion, harbor seal, northern elephant seal, Steller sea lion, and Guadalupe fur seal. Historically, these animals were slaughtered for their pelts, oil, and body parts. Sea lion trimmings (penis and testes) were sold to the Chinese for use in rejuvenation preparations. (DFG.)

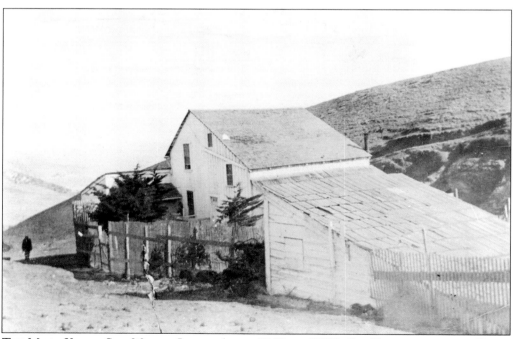

THE MILLS YEARS, SAN MIGUEL ISLAND (FROM 1869 TO 1887). San Francisco attorney Hiram "Hi" Wallace Mills and his hardworking twin brother, Warren Heman "Heem" Mills, entered into business together running sheep on San Miguel, Anacapa, and San Nicolas Islands. In 1872, they formed the Pacific Wool Growing Company, selling company stock to investors. Hiram's son, Dr. Howard Mills, built a two-story, five-bedroom house in Nidever Canyon near the island's fresh water source. (SCIF.)

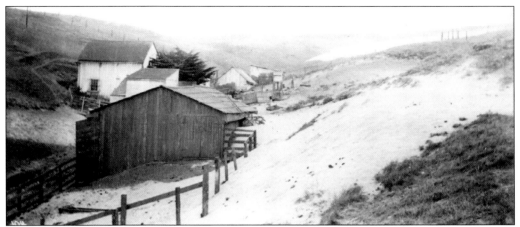

THE MILLS RANCH, SAN MIGUEL ISLAND. The final Mills years were marked by discord between the brothers. Hiram claimed he did all the work while Warren reaped all of the profits. In 1887, Warren Mills sold half of the island to Capt. William G. Waters for $10,000, and in 1888, he sold the other half to Judge Washington Irving Nichols for $10,000. In 1892, Captain Waters acquired 100 percent "ownership" of an island with no deed. (SCIF, photograph by P.V. Reyes.)

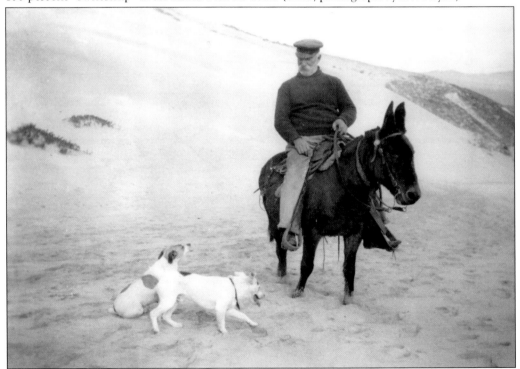

THE WATERS YEARS, SAN MIGUEL ISLAND (FROM 1887 TO 1917). Capt. William G. Waters (1838–1917) moved from San Francisco to San Miguel Island with his second wife, Mirantha "Minnie," and her adopted daughter, Edith. Minnie only stayed for the first five months of 1888; she died of tuberculosis on January 17, 1890. Captain Waters continued to raise sheep on San Miguel Island for the next 30 years. He also held the island's first government lease from 1911 to 1916. (SCIF, photograph by P.V. Reyes.)

ROAD TO THE RANCH, 1903. Capt. William G. Waters developed a dirt wagon road from Cuyler's Harbor to the Mills ranch house, where he lived briefly with his wife, Minnie, and her teenaged daughter, Edith. Shortly after Minnie's death, Edith escaped from the island with a guano collector and sued her stepfather for her inheritance from her mother. In court, she claimed that Captain Waters was abusive and that she led a life "lacking in every comfort." (SCIF.)

THE DEVINES, SAN MIGUEL ISLAND, 1895. After the death of his wife, Captain Waters hired a series of island caretakers, including Mr. and Mrs. Brown, Charles Curryer and his wife, and William E. Devine (in doorway). Devine, accompanied by his mother, Margaret, as housekeeper and younger brother, Francis, as extra help, lived on the island from about 1895 to 1901. (SCIF.)

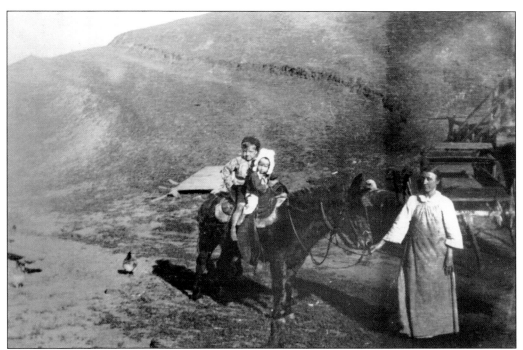

THE RAWLINS FAMILY, 1903. In 1903, Capt. William G. Waters hired Richard and Arklee Rawlins as island caretakers. They moved to the island for a year with their two young children, Fanny and Richard. Arklee wrote in her diary: "My husband's work was to milk the cows and keep the water holes clear of the sand, as we had sand storms which blew and filled them. Sheep would have perished for water." (SCIF.)

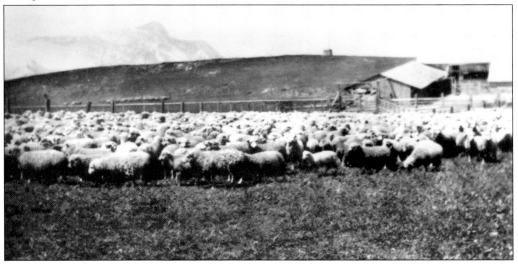

SAN MIGUEL ISLAND SHEEP, 1917. Captain Waters raised sheep on San Miguel Island for 30 years (from 1887 to 1917). When the government enforced its island ownership in 1911, Waters signed a five-year lease, becoming the island's first lessee. Waters renewed for a second five-year term, taking in partners Robert Larkin Brooks and James R. Moore. Waters died in 1917, leaving Brooks and Moore as lessees. They renewed the five-year lease in 1920 for $200 per year. (SCIF.)

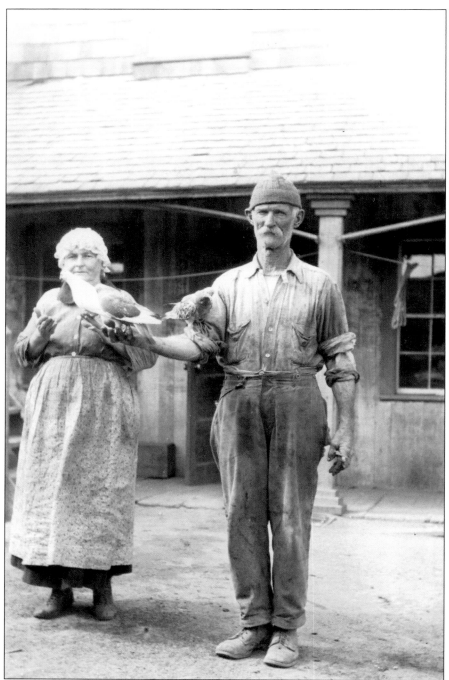

JOHN AND ADA RUSSELL. In 1904, Capt. William G. Waters hired the Russells to live on San Miguel Island; they stayed for 25 years. John Russell helped Captain Waters salvage redwood from the 1905 wreck of the lumber schooner *J.M. Colman* to build a new 120-foot ranch house on top of the island, above Cuyler's Harbor. The Russells stayed on after Captain Waters's death in 1917 and left the island in 1929 because of their advanced ages. (SCIF.)

SAN MIGUEL ISLAND CALICHE, 1910. *Caliche* is derived from the Latin word *calix*, meaning "lime." Composed largely of calcium carbonate, gravel, sand, silt, and clay, the well-developed caliche forest remains as evidence of former trees and shrubs on the island's landscape. Photographer Ralph Paulin captured this image of Santa Barbara–born Horace Sexton (left) and his friend Ed Parker on a visit to the extensive San Miguel Island caliche forest. (SBMNH.)

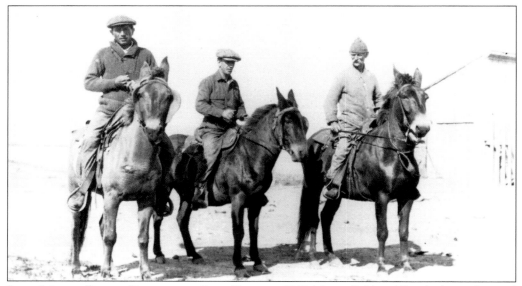

JAMES MOORE, ROBERT BROOKS, AND JOHN RUSSELL, 1917. Moore (left) and Brooks (center) served in the Army during World War I, and Russell (right) and his wife, Ada, took care of San Miguel Island. When the five-year 1920 lease ended in 1925, Moore dropped out. From 1925 to 1948, Brooks was the sole San Miguel Island lessee. In 1929, after 25 years on the island, the Russells moved to the mainland, and Brooks hired his friend Herbert Lester (1888–1942) as island caretaker. (SCIF.)

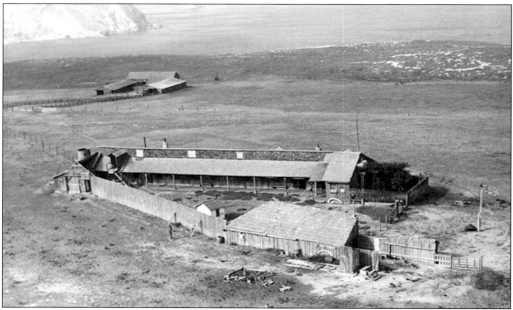

THE BROOKS YEARS, SAN MIGUEL ISLAND (FROM 1917 TO 1948). Herbert Lester and his bride, Elizabeth Sherman, moved to the island in 1930. Lester renamed Captain Waters's eight-room redwood house after the breed of sheep on the island—Rancho Rambouillet. It was built in a long V, creating a courtyard, and portholes served as windows. Elizabeth Lester later recalled, "The house always smelled of tar and kelp and the salt-air that had cured the materials used in its construction." (SCIF.)

THE LESTER FAMILY, SAN MIGUEL ISLAND (FROM 1930 TO 1942). Marianne Miguel was born in 1931, followed by Elizabeth "Betsy" Edith in 1933. The Lesters received nationwide attention for their Swiss Family Robinson–style existence; the girls were schooled on the island in "the tiniest schoolhouse in the world," according to press reports. The family seldom went to the mainland. Robert Brooks had supplies delivered irregularly by boat, weather permitting, and fishermen often visited, leaving fish and supplies. From left to right are Elizabeth, Marianne, Herbert, and Betsy Lester holding Pomo, the dog. (SCIF.)

MARIANNE AND BETSY LESTER BY THE SHEEP SHEDS, 1941. World War II impacted the lives of the Lesters. All boats and planes were grounded, and the Navy assigned sailors to be stationed on San Miguel Island. With his health failing and a fear of eviction, Herbert Lester took his own life on June 18, 1942. Elizabeth, Marianne (left), and Betsy Lester (right) moved to Santa Barbara, and Robert Brooks hired Hjalmar and Rae Englund as caretakers, followed by Al and Rosie Baglin. (SCIF.)

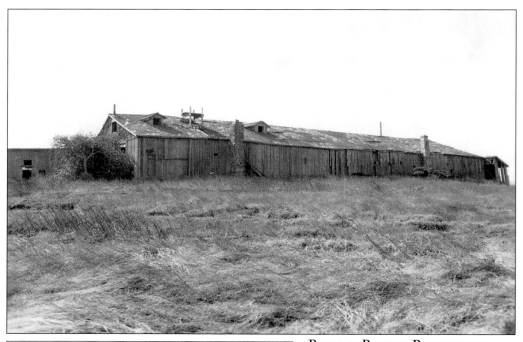

RUINS OF RANCHO RAMBOUILLET, 1965. In 1948, after 32 years as island lessee, Robert Brooks was given a 72-hour eviction notice by the US Navy to remove his thousands of sheep. The island was needed for "military purposes of a confidential nature." In 1963, the Navy transferred management of the island to the Department of the Interior. In 1967, a military flare dropped near the ranch started a fire, which burned the vacant and vandalized Rancho Rambouillet to the ground. (CINP.)

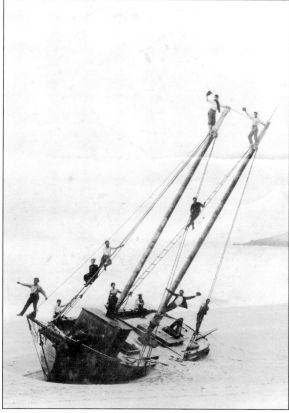

KATE AND ANNA, CUYLER'S HARBOR, 1902. San Miguel Island, known as the Graveyard of Ships, is the site of dozens of maritime accidents, including: *Leader*, 1876; *G.W. Prescott*, 1879; *N.B.*, 1879; *Surprise*, 1881; *Isabella*, 1885; *Challenge*, 1892; *Liberty*, 1895; *Santa Rosa*, 1899; *Kate and Anna*, 1902; *Ariel*, 1903; *J.M. Colman*, 1905; *Anubis*, 1908; *Comet*, 1911; *Iris*, 1913; *Pectan*, 1914; *Mascot*, 1916; *Watson A. West*, 1923; and *Cuba*, 1923. (SCIF.)

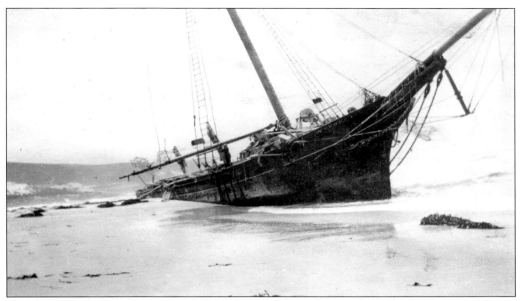

COMET AT SIMONTON COVE, 1911. The 145-foot, three-masted wooden lumber schooner *Comet* was built in Washington for the Pacific lumber trade in 1886. On August 30, 1911, while carrying 620,000 feet of redwood lumber from Gray's Harbor, Washington, to San Pedro, California, *Comet* ran into Wilson Rock off San Miguel Island in a dense fog and then drifted ashore at Simonton Cove. A 24-year-old German crewmember was killed in the accident. (SCIF.)

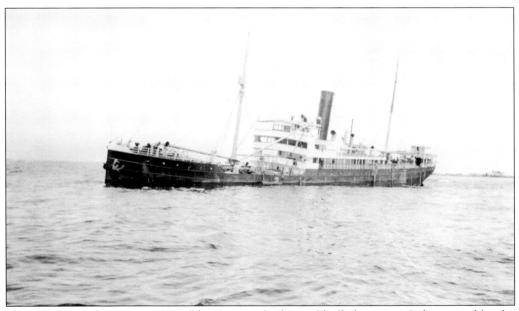

CUBA AT POINT BENNETT, 1923. The German-built, steel-hulled steamer *Cuba*, owned by the Pacific Mail Steamship Company, ran aground on a reef 500 yards off Point Bennett on September 8, 1923. Her 115 passengers and 65 crewmembers were rescued, along with the gold and silver bullion aboard. Ira Eaton, who lived at Pelican Bay on Santa Cruz Island at the time, bought salvage rights from Lloyd's of London and salvaged many of *Cuba*'s furnishings. (SCIF.)

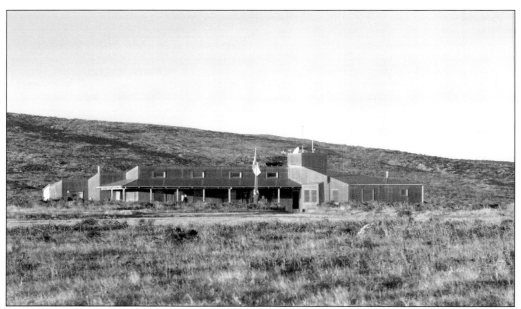

RANGER RESIDENCE, SAN MIGUEL ISLAND, 2011. In 1996, the National Park Service built permanent headquarters on top of the island above Cuyler's Harbor, next to the dirt airstrip and in the vicinity of the nine-site public campground. In addition to ranger's quarters (far right room), the building contains a bunk room with a common kitchen area; two double-bunk rooms and a bathroom; a large office; and a research residence suite with one bedroom, a bathroom, and an open kitchen/living room. (SCIF, photograph by Bill Dewey.)

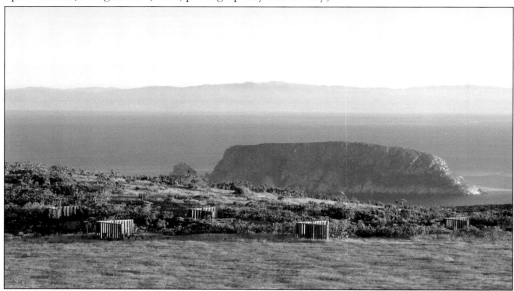

CAMPGROUND, SAN MIGUEL ISLAND, 2011. There are nine primitive camp sites located one mile above Cuyler's Harbor. Each site is provided with a windbreak, a picnic table, and magnificent views of Prince Island. There are pit toilets, no water is available, and no fires are permitted. Reservations can be made through the National Recreation Reservation Service, and there is a $15 per night per site fee. The campground is limited to 30 people. (SCIF, photograph by Bill Dewey.)

Five

WHERE MARINE MAMMALS AND MILITARY MEET
SAN NICOLAS ISLAND

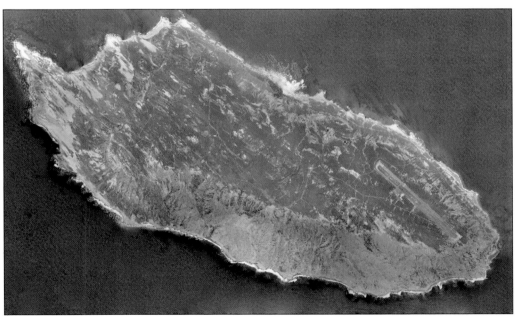

SAN NICOLAS ISLAND, 2002. San Nicolas Island is 22 square miles in size and is the fifth-largest of the eight California Channel Islands. It is the outermost island, 61 miles from the nearest mainland and 28 miles from its closest neighbor, Santa Barbara Island. Jackson Hill, at 907 feet in elevation, is the highest point. San Nicolas Island is in Ventura County and is one of two military islands with no public access. (NAVAIR.)

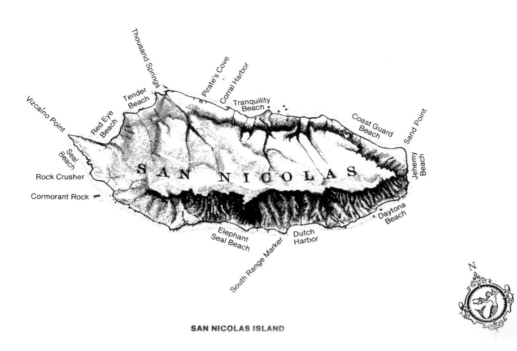

Thousand Springs
Pirate's Cove
Corral Harbor
Tender Beach
Tranquility Beach
Vizcaino Point
Red Eye Beach
Coast Guard Beach
Sand Point
Seal Beach
Jehemy Beach
Rock Crusher
S A N N I C O L A S
Cormorant Rock
Daytona Beach
Elephant Seal Beach
Dutch Harbor
South Range Market

N

SAN NICOLAS ISLAND

SAN NICOLAS ISLAND. San Nicolas Island became US government property when California became a state in 1850. Three years later, Juana Maria, the Lone Woman of San Nicolas Island, was removed from the island and taken to Santa Barbara. From 1902 to 1934, the government leased San Nicolas Island to private sheep-ranching interests. Native terrestrial mammals are limited to the island fox and island deer mouse. (SCIF.)

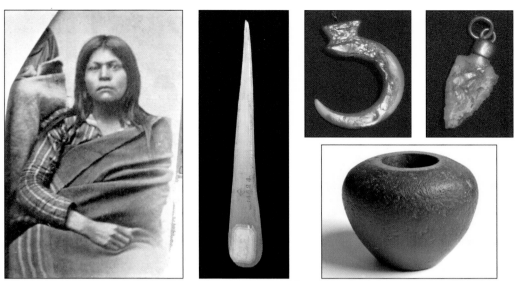

JUANA MARIA, THE LONE WOMAN OF SAN NICOLAS ISLAND. The story of Juana Maria, lone woman of San Nicolas Island, is well known in California history. Rescued from the island after having lived alone for 18 years, this last Nicoleño arrived in Santa Barbara on September 8, 1853, and died barely six weeks later, on October 19. Four of her possessions have survived: an abalone fishhook, a stone bird point, a whale baleen hairpin, and a steatite donut stone. (Portrait: SWM; hairpin: AMNH; fishhook, bird point, and stone: SCIF.)

CORRAL HARBOR, SAN NICOLAS ISLAND, 1907. In 1858, Capt. Martin Morse Kimberly (1826–1878) filed a claim for 160 acres at Corral Harbor, where he kept sheep, cattle, and horses for 14 years. In 1870, Kimberly sold "all houses, buildings, corrals, wells, and improvements thereon" to Abraham Halsey and William Hamilton for $18,000. In 1872, the Pacific Wool Growing Company acquired these assets. The government began leasing San Nicolas Island in 1902. (Gladys Bibb.)

STEPHEN AND DeMOSS BOWERS ON SAN NICOLAS ISLAND, 1889. Rev. Stephen Bowers (1832–1907), right, was among the first to excavate burials on San Nicolas Island. He trained his son, DeMoss (1864–1917), left, to follow in his footsteps. They often camped in crude shelters or tents while working on the Channel Islands. Artifacts they collected can be found in museums around the world. The Smithsonian was one of their best customers. (SBMNH.)

EXPEDITION TO SAN NICOLAS ISLAND, MAY 1907. DeMoss Bowers spent two weeks excavating on San Nicolas Island with friends John Von Blon (1871–1957), artist Arthur B. Dodge (1863–1952), and photographer Harry Tingle. Von Blon noted: "When the boat went to bring us back, the Press and the Associated Press reported us lost. When finally rescued, we were out of food—hungry!" (Gladys Bibb.)

John Von Blon in His Tent, May 1907. "Our home for two weeks on one of the world's loneliest islands. Utterly uninhabited. The tent had to be anchored with heavy rocks and was threatened day and night by heavy gales common to the island. A rocky waste in a turbulent sea. Mighty breakers crash. Spray flies high. Sands shift forever in the wind," wrote Von Blon. (Gladys Bibb.)

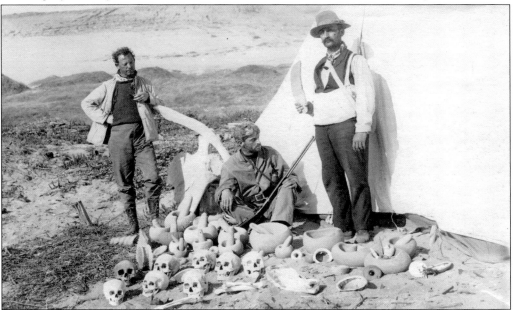

Tent Camp, May 1907. Hunting for Indian relics was a popular pastime in the late 19th and early 20th centuries. San Nicolas Island was overgrazed by sheep, and huge shell mounds left by the Nicoleño lay exposed, attracting archaeologists and pot hunters. DeMoss Bowers organized this San Nicolas Island expedition four months after his father died. Pictured here are artist Arthur Dodge (left), John Von Blon (center), and Bowers. (Gladys Bibb.)

LOOKING SOUTH, SAN NICOLAS ISLAND, MAY 1907. The island is relatively flat at the top, with a mesa-like profile. The northern side has slopes that rise to 300 to 400 feet above sea level. Leeward is an escarpment that rises to 700 feet within a mile of shore. Bowers and friends hiked miles from their camp at Corral Harbor, on the north side of the island, in search of Nicoleño artifacts. (Gladys Bibb.)

C.B. LINTON ON SAN NICOLAS ISLAND, 1910. Sheep rancher Joseph Garcia Howland held concurrent government leases on Santa Barbara Island (from 1909 to 1914) and San Nicolas Island (from 1909 to 1919). Howland was a friend of ornithological collector Clarence Brockman Linton (1881–1925). In 1909, Linton met and married Texas-born socialite Lillian McClelland, and they spent their three-month honeymoon on San Nicolas Island. Linton eventually collected more than 1,000 bird specimens on various Channel Islands. (SCIF.)

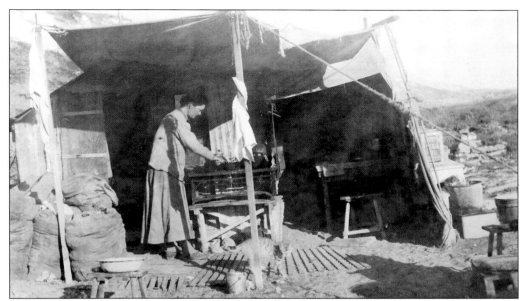

LILLIAN LINTON IN CAMP, 1910. The former glove-wearing society bride Lillian Linton spent her extended honeymoon pregnant and living in a primitive tent camp lacking in every convenience. She quickly became accustomed to tanned hands, hard work, and complete isolation. Linton noted in her diary that she learned to skin birds, eat plover, butcher sheep, render seals, and cook abalone. She befriended elephant seals that dwarfed her in size. (SCIF.)

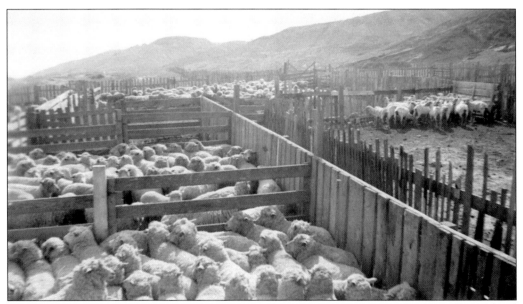

SHEEP CORRALS AT THE RANCH ON SAN NICOLAS ISLAND. From 1919 to 1934, Santa Rosa Island rancher Edward N. Vail held the San Nicolas Island lease. He built a small house, a dock, and corrals and made other improvements. In 1924, in partnership with San Miguel Island lessee Robert Brooks, 2,500 sheep were transferred from San Miguel Island to San Nicolas Island. Lyman and Edna Elliott were hired as caretakers in March 1929. (SCIF.)

SAN NICOLAS ISLAND RANCHING FAMILIES, 1933. Roy and Margaret Agee and their daughter Frances moved to San Nicolas Island in 1929 to help Margaret's parents, Lyman and Edna Elliott, oversee the island's sheep operations. The Agees' son Roy was born in 1935 while they were working on the island. Pictured here are, from left to right, (standing) Margaret and Roy Agee, Edna and Lyman Elliott, Agnes Mundon, Ed Rucker, an unidentified friend, and teacher Winona McAllister; (on the ground) Shorty Daily and six-year-old Frances Agee. (SCIF.)

SLED, SAN NICOLAS ISLAND, 1931. Roy Esco Agee (1901–1979) used a horse-drawn sled to haul materials and supplies on the island. Four-year-old Frances (1927–2001) hitched a ride. In 1933, the island was transferred to the US Navy, but sheep ranching continued. Robert Brooks sold the island assets—sheep, horses, cows, equipment sheds, fencing, and houses—to the Elliotts and the Agees prior to the expiration of Edward Vail's lease in 1934. (SCIF.)

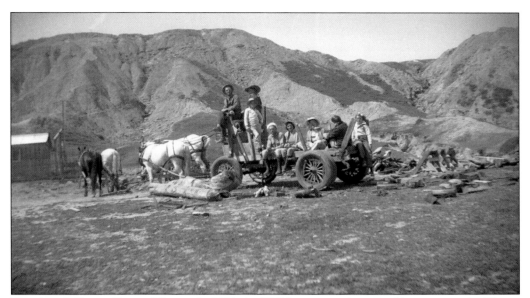

ROY AGEE'S TRUCK-FRAME WAGON. In 1934, the US Navy granted a revocable permit to the Elliotts and Agees that allowed them to continue sheep ranching. From February 1937 to June 1938, Roy McWaters and his family moved to San Nicolas Island to help manage the ranch. Pictured here are, from left to right, Roy McWaters, Roy Agee, Jimmy McWaters, an unidentified Navy couple, Mrs. McWaters, teacher Winona McAllister, and Frances Agee. (SCIF.)

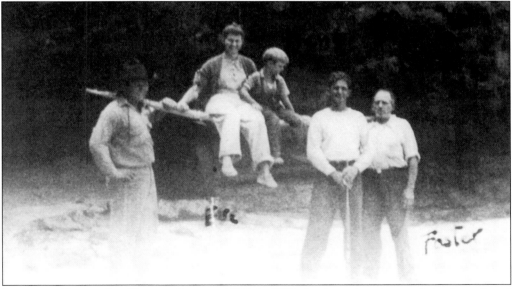

LAMBERTH FAMILY, SAN NICOLAS ISLAND, 1938. In 1937, the Agees bought a mainland ranch and needed island help. In 1938, when the McWaters family left, the Agees hired Reggie Lamberth and his family as managers. In 1939, the Agees bought out the Elliotts' interests, and Margaret Agee's parents (the Elliotts) moved to Buellton, California. Pictured here are, from left to right, Reggie and Evelyn Lamberth, Dennis Lamberth, Alfred Perry, and Evelyn's father, Theodore Foster. (Jeannie Lamberth Hess.)

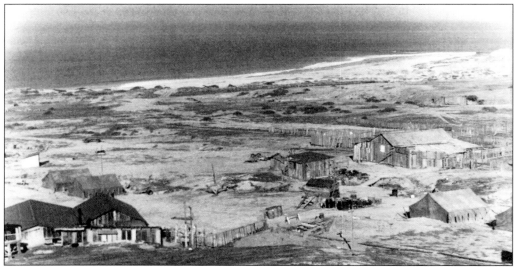

BROOKS LANDING, SAN NICOLAS ISLAND RANCH, 1942. The Lamberth family lived on the island from June 1938 until the fall of 1939, and in February 1940, the McWaters family returned for another year. The ranch complex was located on a coastal plain on the island's north shore. The main ranch house is at lower left; the barn and blacksmith shop are to the right. (Stanley Wheeler.)

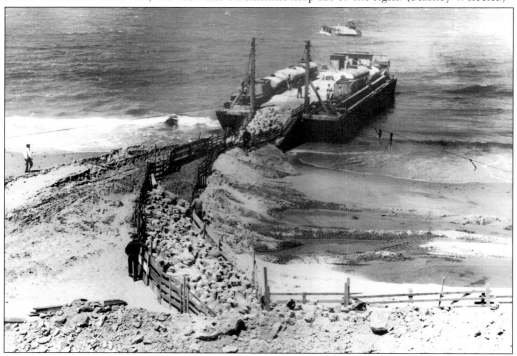

SHIPPING SHEEP, 1943. Almost 3,000 sheep were sheared in July 1939. San Nicolas Island sheep were said to be among the best in Southern California. With the onset of World War II, the Navy revoked the grazing rights of the Agees and Elliotts, and they were forced to remove their sheep. Most were shipped off by tugboat and barge. The US Army took control of the island during the war. (SCIF.)

WARTIME CONSTRUCTION ON SAN NICOLAS ISLAND, 1943. During the war years, the Army constructed extensive facilities southeast of Brooks Landing on the island. Before the end of the war, the island was returned to Navy control, and it was placed in caretaker status after the end of the war. In 1946, the Naval Air Missile Test Center was created, and the island was placed in its jurisdiction. (NAVAIR.)

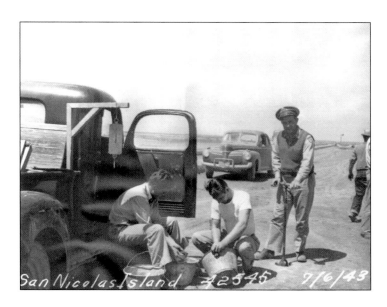

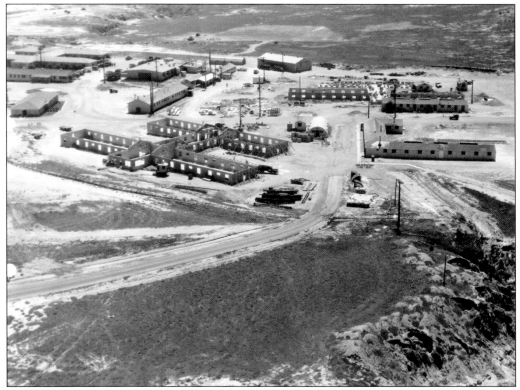

SAN NICOLAS ISLAND BARRACKS CONSTRUCTION, 1959. The island has remained under the jurisdiction of the US Naval Air Station (NAS) Point Mugu since the end of World War II. Military facilities have grown ever since. Permanent structures include barracks, technical facilities, a mess hall/cafeteria, medical and fire facilities, a Navy exchange, tennis and racquetball courts, a weight room, a movie theater, a bowling alley, and a recreation center. (NAVAIR.)

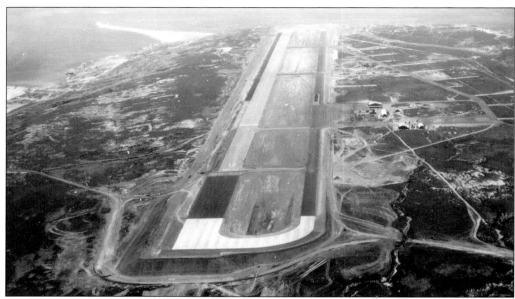

AIRFIELD, SAN NICOLAS ISLAND, 1959. As Edward Vail's island lease was ending, the first airfield was built on the island in 1933 and 1934, marked with a windsock and metal ground markers. Today, there is a modern 10,000-foot paved runway on the mesa at the southeast end of the island. It has a ground-controlled approach facility and can accommodate supersonic aircraft. (NAVAIR.)

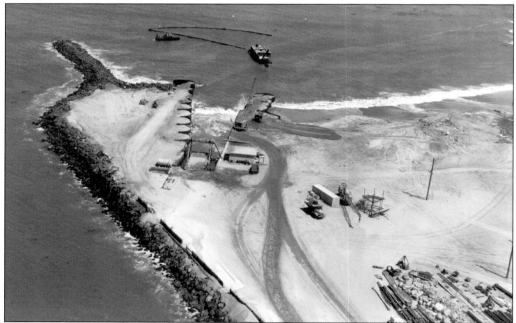

BARGE LANDING, 1968. The road system on San Nicolas Island consists of both paved and unpaved roads. Jackson Highway traverses most of the length of the island, from the airfield in the east to the far west end. The bulk of supplies are sent by barge or cargo plane. During World War II, the Army established the first barge landing site at Coast Guard Beach. This location was used until the mid-1970s, when the barge operation was moved to Daytona Beach. (NAVAIR.)

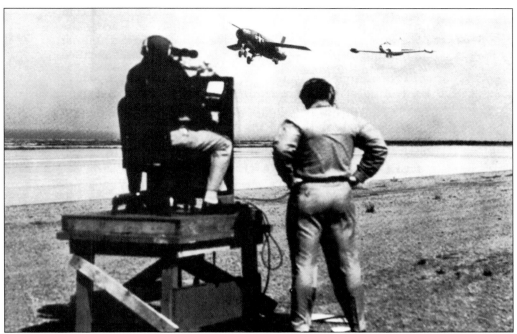

REGULUS RECOVERY, 1957. Among other activities, San Nicolas Island installations are used to study both internal and external missile data using radar, telemetry, photography, and other means. The Regulus cruise missile was America's first nuclear-armed, submarine-launchable missile, in service from 1955 to 1964. US Navy ships carried Regulus missiles on operational patrols in the Western Pacific. A prototype test flight was carried out at the island, and the missile was successfully recovered. (NAVAIR.)

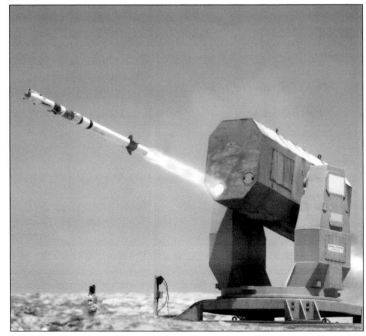

ROLLING AIRFRAME MISSILE, 1984. Early development and testing of Rolling Airframe Missiles (RAM) occurred on San Nicolas Island. These small, lightweight, passive, infrared homing surface-to-air missiles are so named because they roll around their longitudinal axis to stabilize their flight path, like a bullet fired from a rifle. Heat-seeking RAMs contain sensor packages at the tip of the missiles, which are fired from launchers directed at targets. (NAVAIR.)

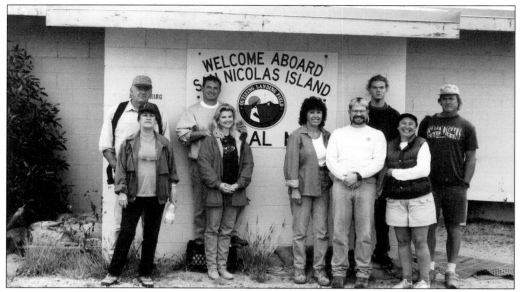

SAN NICOLAS ISLAND AIRPORT, 1999. San Nicolas Island is closed to the public, although limited scientific access and special projects may be permitted. Weekday flights from Point Mugu Naval Air Station aboard contracted Gulfstream III jets take 25 minutes each way on average and carry 24 to 30 personnel. Pictured here are, from left to right, Keith and Loren Herold, Chip and Leslee Wullbrandt, Marilyn Goodfield, Robert Schwemmer, Aaron Gauss, Marla Daily, and Kirk Connally. (SCIF.)

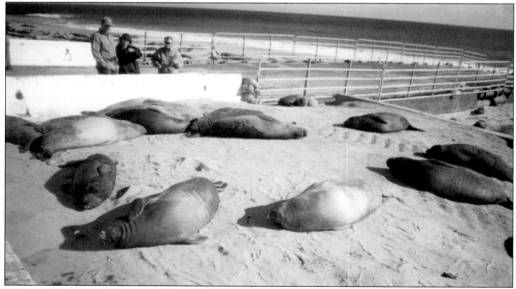

MARINE MAMMALS MEET THE MILITARY, 2001. The ever-expanding population of elephant seals, which breed and haul-out on San Nicolas Island, often block coastal roadways. Cement barriers keep the animals off the military's right-of-way. By the end of the 19th century, elephant seals had been hunted to near-extinction, and only a remnant population at Mexico's Guadalupe Island allowed them to survive. Today, the population has rebounded to include more than 175,000 animals. (SCIF, photograph by Keith Westcott.)

Six

BUCKING THE CHALLENGE
SANTA BARBARA ISLAND

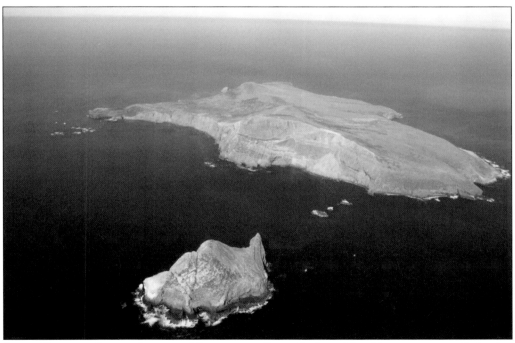

SANTA BARBARA ISLAND LOOKING NORTHWEST. Santa Barbara Island is one square mile in size, about 639 acres, and is the smallest of the eight California Channel Islands. It is 38 miles from the nearest mainland and 24 miles from Santa Catalina Island, its closest neighbor. Signal Peak, at 635 feet in elevation, is the island's highest point. Santa Barbara Island is in Santa Barbara County and is one of five islands in Channel Islands National Park. Sutil Rock, off the island's southwest quarter, is about 10 acres in size. (SCIF, photograph by Bill Dewey.)

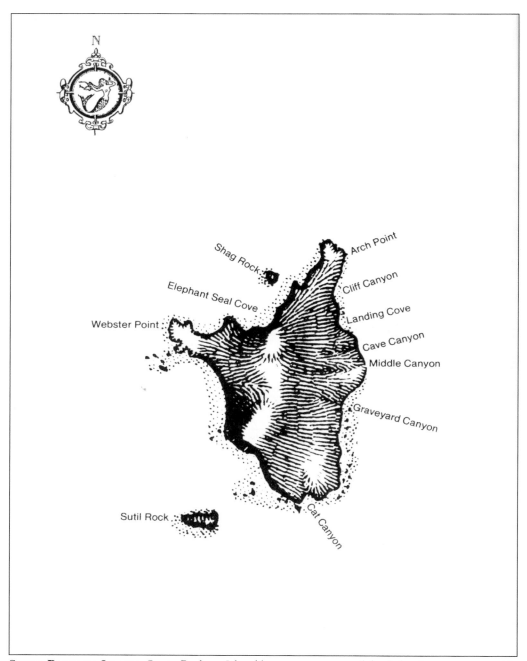

Santa Barbara Island. Santa Barbara Island became property of the federal government with California statehood in 1850. Sealers and fishermen used the island at will through the turn of the 20th century. From 1909 through 1929, the government leased Santa Barbara Island off and on to private individuals. In 1938, under President Franklin Roosevelt's Antiquities Act, Santa Barbara Island became part of Channel Islands National Monument. In 1980, Channel Islands National Park, which includes Santa Barbara Island, was created. The island deer mouse is the island's only native terrestrial mammal. (SCIF.)

HEMAN BAYFIELD "BAY" WEBSTER, SANTA BARBARA ISLAND, C. 1900. When California became a state in 1850, unclaimed and uninhabited Santa Barbara Island changed ownership from Mexico to the United States. For the remainder of the 19th century, this small oceanic outpost was occupied seasonally by fishermen, transient seal hunters, and Chinese lobster trappers. Bay Webster lived on Santa Barbara Island part-time in a shack he built on the point that now bears his name. (MVC.)

WEBSTER POINT, SANTA BARBARA ISLAND, 1982. In the 1890s, Bay Webster built a wooden shack on the northwestern part of the island where he lived part-time as a fisherman and seal hunter. He refocused his interests on Anacapa Island when he won that island's 1907 government lease. The first Santa Barbara Island lease, from 1909 to 1914, was awarded to Joseph Garcia Howland (1862–1923). When it expired, Howland did not renew. (SCIF, photograph by Marla Daily.)

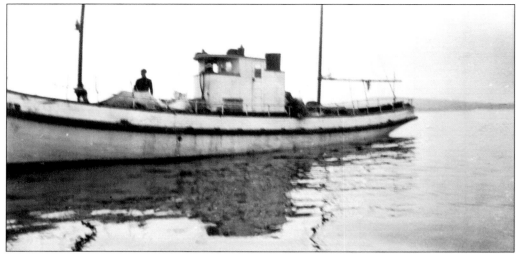

ALVIN HYDER'S BOAT, NORA II. Alvin Hyder (1881–1938) of San Pedro won the second Santa Barbara Island lease (from 1914 to 1919). The hardworking extended Hyder family raised sheep, goats, and pigs; kept poultry; introduced rabbits; grew crops; and even cultivated hay as a commercial venture—all on an island with no fresh water! Although the Hyders lost the 1919 lease bid, they stayed for almost another decade. Winning lessee Abbott Kinney defaulted in 1920, and another lease was not issued until 1929. (SCIF.)

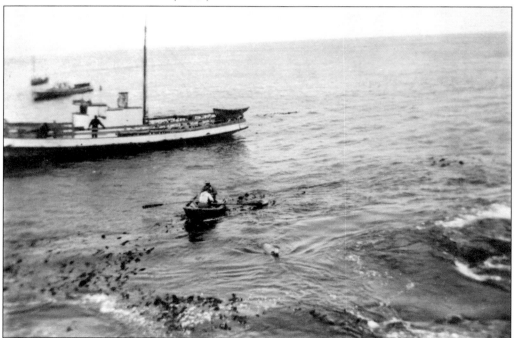

OFF-LOADING SHEEP BY SKIFF AT SANTA BARBARA ISLAND, C. 1918. For two decades, from 1918 to 1938, Alvin Hyder ran the *Nora II* as a business, hauling sheep, shearing crews, wool, and supplies to the other islands for various resident ranchers. During Prohibition, Hyder used *Nora II* to haul bootleg liquor. On the pierless Santa Barbara Island, sheep were hog-tied and transported by skiff to and from the island. (SCIF.)

BUSTER HYDER WORKING ON THE DOCK, C. 1918. Denton Ozias "Buster" Hyder was born in San Pedro in 1905. He was 10 when his father, Alvin Hyder, secured the Santa Barbara Island lease. Alvin and his brothers Cleve and Clarence built homes on the island for their extended family. They lived by lanterns and hauled fresh water from the mainland. Buster lived a childhood of island isolation and hard labor. (SCIF.)

LOADING SHEEP ON THE GEAR SLED, SANTA BARBARA ISLAND, C. 1918. The Hyders built a gear sled on tracks that ran from a platform at Landing Cove to the top of the island. As Buster Hyder recalled: "When we got ready to ship sheep, we put up just regular wing fences to drive them in. We'd hog-tie them, load them in the sled, and then let it down the hill." (SCIF.)

ALVIN HYDER (RIGHT) WORKING THE SLED LINES, C. 1918. The sled was let down by ropes, taking turns around posts. Al Hyder's son, Buster, remembered: "It was hard work, 'cause it was pretty heavy when you got 10 head of sheep in there." From the bottom of the sled, the sheep were rowed out to the *Nora II*, which was anchored offshore. Horses were used to pull the sled back up the tracks. (SCIF.)

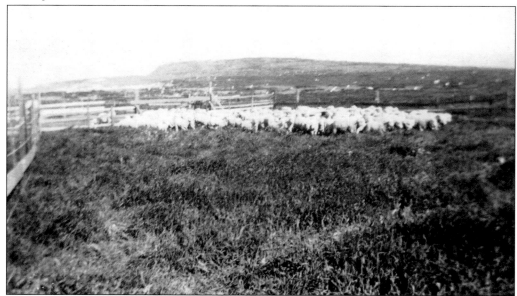

SHEEP CORRALS ABOVE ELEPHANT SEAL COVE, SANTA BARBARA ISLAND, C. 1918. As Buster Hyder explained: "We brought the sheep to Santa Barbara Island. We took about 300 sheep to that island. We bought them from Caire on Santa Cruz Island. They were Rambouillets. We just let them go all over Santa Barbara Island. My dad was definitely the first person to take sheep out there." (SCIF.)

CLEVE HYDER SHEARING SHEEP ON SANTA BARBARA ISLAND, C. 1918. Grover Cleveland "Cleve" Hyder (1884–1959) was the youngest of 12 Missouri-born siblings, several of whom migrated to the California coast at Bolsa Chica (Huntington Beach). Cleve Hyder worked as an engineer on local fishing boats before moving to Santa Barbara Island, where he hand-sheared sheep, dry-farmed crops, and fished for lobsters. Like his older brother, Alvin, he was an extremely hard worker. (SCIF.)

CLEVE AND MARGARET HYDER'S HOUSE, C. 1918. Cleve built his house—one large room—halfway up from Landing Cove in a gulley that often flooded in winters. He and Margaret had no children. Margaret gave Buster and his older sister, Nora, what limited school lessons they had. As Buster recalled, "Aunt Margaret took the old apple boxes out and made the seats, and we went to school right in the house." (SCIF.)

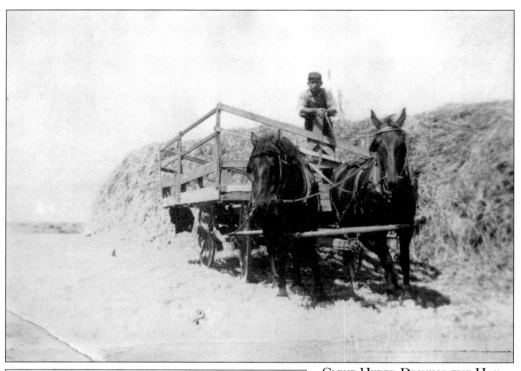

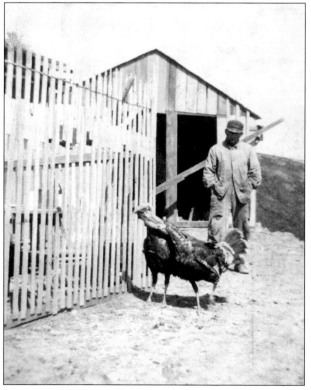

CLEVE HYDER DRIVING THE HAY WAGON, C. 1918. "We brought the hay baler over on the deck of the boat, and we brought that thing up with a cable. The cable broke when we were pretty near the top and it went tumblin' into the water. We had to fish it out," recalled Buster. One hay crop was grown, cut, baled, hauled to the mainland, and sold, only to have the buyer go bankrupt. (SCIF.)

ALVIN HYDER OUTSIDE THE BARN, SANTA BARBARA ISLAND, C. 1918. "Dad was a hard-working man who never knew when to stop. He wouldn't give up," his son, Buster, recalled. "Our house had big cables on the west side of it to keep it from blowin' over the hill when them hard winds would come up. We watched more gosh darn chickens and turkeys blow out in that ocean." (SCIF.)

NAVIGATIONAL LIGHT, SANTA BARBARA ISLAND, C. 1982. The Hyders had moved off the island by the late 1920s, and the last island lessee defaulted on the 1929 lease. In 1932, leasing was cancelled. In late 1929, a navigational light was placed on the island's northwest corner (right); in 1934, a second light was constructed at the south end. In 1938, Santa Barbara Island became a part of Channel Islands National Monument. (SCIF, photograph by Marla Daily.)

BIOLOGICAL SURVEY TEAM ON SANTA BARBARA ISLAND, 1939. Staff of the Los Angeles County Museum conducted a Channel Islands Biological Survey of all eight islands from 1939 to 1941. From May 27 through 30, 1939, the team visited Santa Barbara Island. Pictured here are, from left to right, Theodore Reddick, Meryl B. Dunkle, Jack C. Von Bloeker, Lloyd Martin, James DeLong, and Russell Sprong. Arthur Woodward and Don Meadows (not pictured) also participated. World War II stopped the survey. (SL, photograph by Don Meadows.)

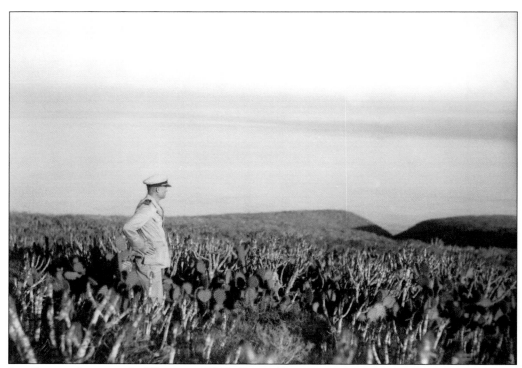

Lt. Comdr. Stanley A. Wheeler, USN, Santa Barbara Island, 1942. From 1942 to 1946, the island served as a military outpost. Two barracks, water tanks, and a garage were built atop the island. In 1942, the island's two lights were extinguished. They were relit in 1943, when the threat to Los Angeles was thought to be over. After the war, the lights continued to be maintained by the Coast Guard. (CINP.)

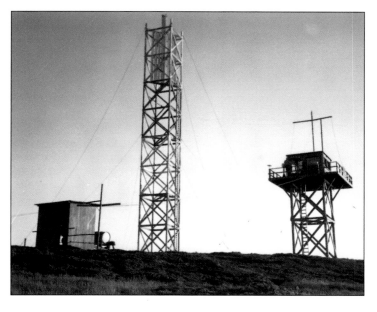

Coastal Lookout, Santa Barbara Island, 1942. During the war, Coast Guard and Navy personnel manned coastal lookout stations on all eight California Channel Islands, using portable radios, transmitters, and receivers. On Santa Barbara Island, lumber from the Hyders' house was reused to build two side-by-side barracks connected by an enclosed hallway. The coastal lookout system was abolished on July 1, 1945, and the facilities were abandoned. (CINP.)

QUONSET HUTS, SANTA BARBARA ISLAND, C. 1964. In 1959, a fire destroyed the remains of the lookout tower and other structures. In the early 1960s, the Naval Ordnance Test Station, China Lake, installed a tracking station atop Santa Barbara Island to record flights of test rockets. The Navy constructed two 48-foot-by-20-foot Quonset huts, which were transferred to the National Park Service as surplus when the Navy left. (CINP.)

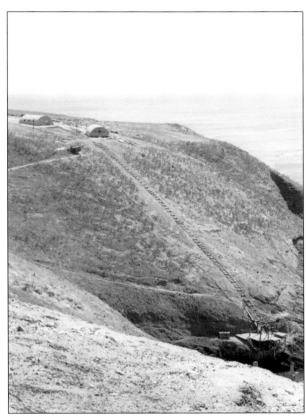

QUONSET HUT, SANTA BARBARA ISLAND, 1975. By the 1970s, only one Quonset hut remained. Botanist Ralph Philbrick and geologists J.G. Vedder and David Howell visited in May 1975. Philbrick, director of the Santa Barbara Botanic Garden, began studying the island's flora in 1962. He published the *Plants of Santa Barbara Island* in 1972 and revised the text in 1993. In 1980, Santa Barbara Island became part of Channel Islands National Park. (SCIF, photograph by David Howell.)

BUSTER HYDER, SANTA BARBARA ISLAND, 1986. After a 60-year absence, Hyder, then 81, returned to hike the island and recall his youth. "A lotta times we had to drink mice water. It was terrible. I took the mice out of the water everyday. I had a long cane pole with holes in it so the water drained out around 'em. Boy, it was hard to drink it." (SCIF, photograph by Bill Dewey.)

BUSTER HYDER REVISITS SANTA BARBARA ISLAND, 1986. Accompanying Hyder to Santa Barbara Island in 1986 were, from left to right, William Ehorn, superintendent, Channel Islands National Park; Steve Junak, Santa Barbara Botanic Garden; Don Morris, archaeologist, Channel Islands National Park; Seth Hammond, helicopter pilot; Buster Hyder; and Marla Daily, Santa Cruz Island Foundation. Hyder's recollections were recorded as he described his youth of hard work and hardship. (SCIF, photograph by Bill Dewey.)

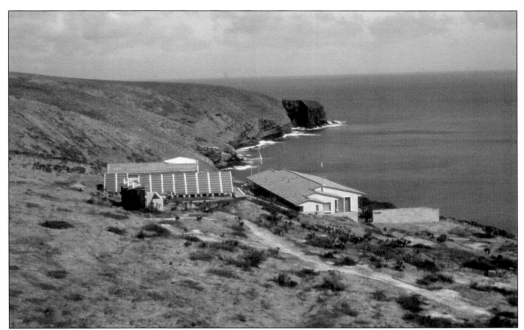

RANGER RESIDENCE AND VISITOR CENTER, SANTA BARBARA ISLAND, 1994. The park service has reconstructed the dock at Landing Cove several times since 1990; the dock has been repeatedly wiped out by storms. In 1991, a building housing ranger quarters, a bunkhouse to accommodate four researchers, and a visitors' center were built at the site of the last remaining Quonset hut. Water is delivered by boat and pumped from Landing Cove to tanks on top of the island. (SCIF, photograph by Marla Daily.)

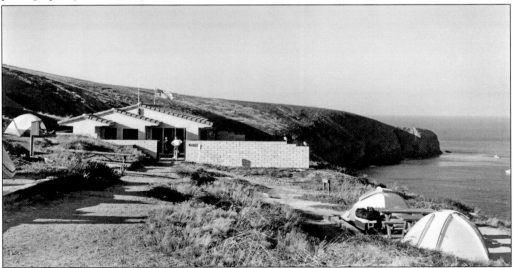

CAMPGROUND, SANTA BARBARA ISLAND, 1994. There are nine primitive campsites and nearby outhouses located on an exposed coastal bluff atop the island, accessed by a half-mile-long steep narrow dirt trail from Landing Cove. The island is treeless, and no water or shade is provided for campers. No fires are allowed, but propane/gas camp stoves are permitted. Reservations are required, and campers may stay for up to a week. (SCIF, photograph by Bill Dewey.)

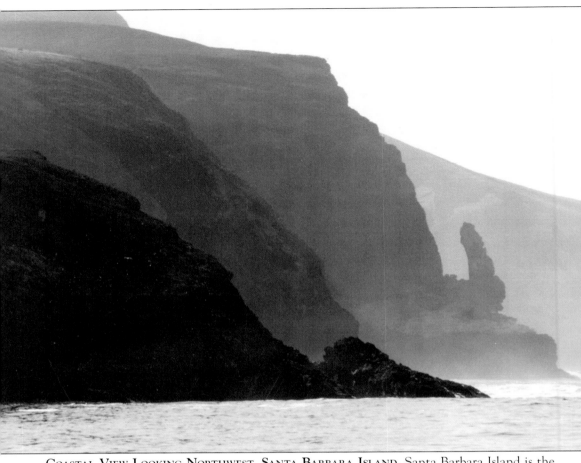

COASTAL VIEW LOOKING NORTHWEST, SANTA BARBARA ISLAND. Santa Barbara Island is the smallest and most remote of the Channel Islands. Island Packers, concessionaire to Channel Islands National Park, has been transporting visitors to Santa Barbara Island since 1970. Trips are run from Memorial Day weekend throughout the summer months. Six miles of nature trails loop around and over the top of the island. Native island inhabitants include seabirds and brown pelicans, which nest on the island; great numbers of endemic Santa Barbara Island deer mice; and elusive island night lizards. (SCIF, photograph by Bill Dewey.)

Seven

19TH-CENTURY PLEASURE-SEEKERS
SANTA CATALINA ISLAND

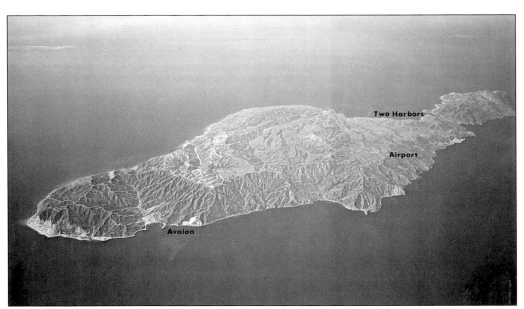

SANTA CATALINA ISLAND FROM 25,000 FEET. Santa Catalina Island is the third largest of the California Channel Islands. It is 75 square miles in area, or about 48,000 acres, and is approximately 21 miles long and up to eight miles wide. The island is 19.7 miles from the nearest mainland at the Palos Verdes Peninsula and 21 miles from San Clemente Island, its closest neighbor to the south. Mount Orizaba, at 2,070 feet in elevation, is the island's highest point. Santa Catalina Island is in Los Angeles County. (SCICo.)

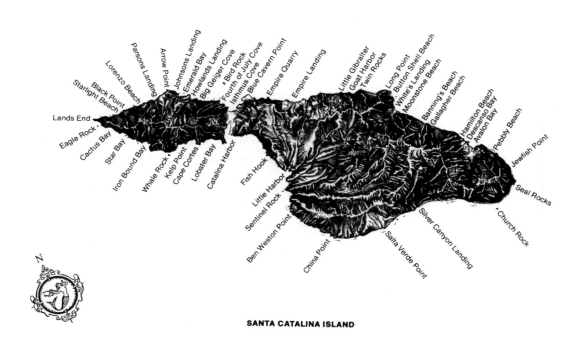

SANTA CATALINA ISLAND

SANTA CATALINA ISLAND. Santa Catalina Island was the third of three islands granted into private ownership under Mexico's rule of Alta California. In 1846, Thomas Robbins received Santa Catalina Island as a gift from Gov. Pio Pico. This is the only California Channel Island developed by its private owners for the public. Native terrestrial mammals are limited to the island fox, California ground squirrel, ornate shrew, island deer mouse, and harvest mouse. (SCIF.)

JOHNSONS LANDING (EMERALD BAY). In 1846, Mexican governor Pio Pico granted this third-largest Channel Island to American Thomas Robbins. Robbins sold the island to José María Covarrubias in 1850, and a series of investors followed. In 1854, Danish immigrant John Frederick Johnson (1830–1893) began squatting on the island, raising both sheep and cattle. In 1868, Johnson married Martha Bennett. The first of their eight children, Josephine, was born on the island in 1869. (SCICo.)

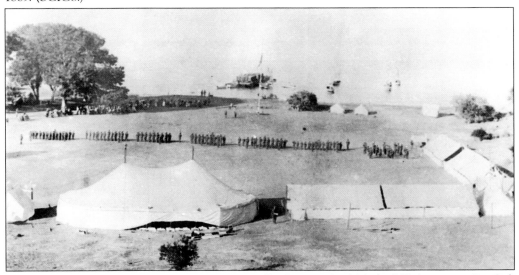

CIVIL WAR TROOPS, CATALINA HARBOR, 1864. On January 1, 1864, the US Army sent Lt. Col. James Curtis and his infantry to take possession of Santa Catalina Island as a proposed Indian reservation. About 100 people were living on the island, half of whom were transient hopeful miners. Ranching squatters included John Johnson, Juan Cota, William Howland, Sven (Swain) Larsen, Spencer Wilson, and Thomas Whittley. There were horses, cattle, goats, and 15,000 sheep on the island. (SCICo.)

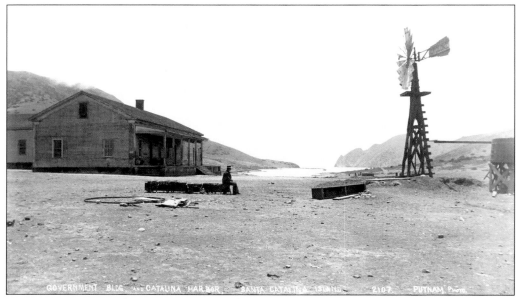

JAMES LICK'S ISLAND (FROM 1867 TO 1887). Civil War troops left in September 1864, leaving barracks behind. In 1864, real estate investor James Lick (1796–1876), seated, began reuniting the island's ownership, and he owned the island by 1867. Lick evicted most of the squatters, granting rights to a few, including Thomas Whittley, William Howland, and Ben Weston. In 1874, two years before his death, Lick created a $3-million trust with trustees taking title to Santa Catalina Island. (CIM.)

BEN WESTON'S BEACH. On January 1, 1864, Benjamin Stone Weston (1832–1905) sailed to the Isthmus at Santa Catalina Island as a corporal of the 2nd Regiment, California Cavalry. When military personnel left in September, Weston stayed to raise sheep under a 10-year lease (from 1864 to 1874) from James Lick. Weston bought extensive agricultural holdings in Torrance, California, where he and his friend, William Howard, lived for more than 30 years. Weston died in 1905 at age 73 and is buried in Wilmington Cemetery next to Howard. (SCICo.)

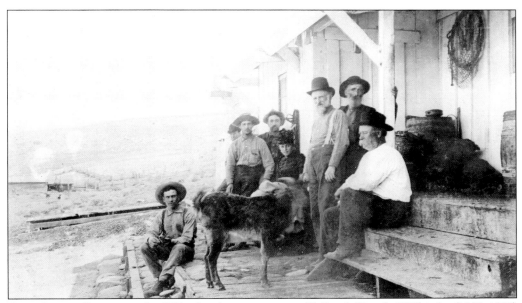

EARLY ISLAND SHEPHERDS. In 1855, when he was six years old, Frank "Pancho" Whittley (1848–1902) moved to the island from Ensenada, California, with his parents, Thomas Whittley and Juanita Domingues. For much of his adult life, Frank (seated right) was in charge of raising sheep on Santa Catalina Island. Frank was well known for his mutton jerky, which was made with a lot of chilies and tomato paste "so damned hot the flies and other bugs couldn't take it." (HL.)

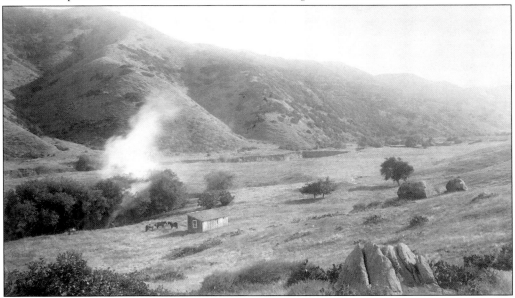

MIDDLE RANCH, SANTA CATALINA ISLAND, C. 1892. Frank Whittley started Middle Ranch with lumber he hauled to Goat Harbor and transported by burro. Eagle's Nest, Empire Landing, and Catalina Harbor sheep camps were also under his supervision. In 1898, Whittley was 25-percent owner (25 shares) and superintendent of the newly formed Banning Wool Company. In the 1890s, he also ran sheep on neighboring San Clemente Island. Whittley died in 1902 at age 54 in Los Angeles. (CIM.)

137 L

Time 1 hr. 10m

CAUGHT BY HW. L'ACE
AT CATALINA ISLd.

"MEXICAN JOE" PRESIADO, 1902. In 1855, at age seven, José Felice Presiado (1848–1919) was brought to Santa Catalina Island from Mexico by Thomas Whittley as a companion for his six-year-old son, Frank (also known as Poncho); Presiado never left. In the 1880s, he used Johnson's Landing as a hunting lodge; in the 1890s, he became famous as a boatman. His was the first boat for hire in the island community of Avalon. In 1895, Charles Frederick Holder wrote: "Mexican Joe has lived 40 years or more on Santa Catalina Island, and all the inalienable rights and privileges that go to the office of the oldest inhabitant are his: moreover, he is, by common repute, the lineal descendant of a soldier of Montezuma, and his strong, clear-cut features carried out the idea of an Aztec lineage. Being so invested by legend, Joe is considered an authority on all matters appertaining to sport on the isle of Summer." Presiado died on March 3, 1919, at age 77 and is buried in Avalon Municipal Cemetery. (CIM.)

SVEN LARSEN, 1901. Sven Larsen was born in Norway in October 1823. He immigrated to California at age 30 and soon made his way to Santa Catalina Island. In 1864, when Civil War troops arrived at the Isthmus, Larsen had already been squatting on the island for almost a decade, and he owned 10 head of cattle. Divorced and alone, he became well known as the Hermit of Santa Catalina Island. For more than 45 years, Larsen lived up the coast from Avalon in Swain's Valley—a misspelling of his first name, Sven. Before the turn of the century, Swain's Landing became the site of the Whittier Boys and Girls Camp. It is now known as White's Landing. (CIM.)

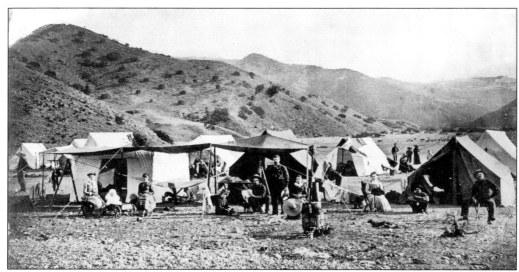

TIMMS' LANDING (AVALON), 1879. In the 1850s, German immigrant Augustus William Timms (c. 1825–1888) developed facilities in San Pedro Harbor to serve increasing shipping needs. He diversified into the Santa Catalina Island sheep business in the 1860s, using his vessels *Ned Beal*, *Pioneer*, and *Rosita* for cross-channel transport. *Rosita* took passengers across the channel for bathing and fishing. Pleasure-seekers set up tents along the beach at Timms' Landing, which was later renamed Avalon. (CIM.)

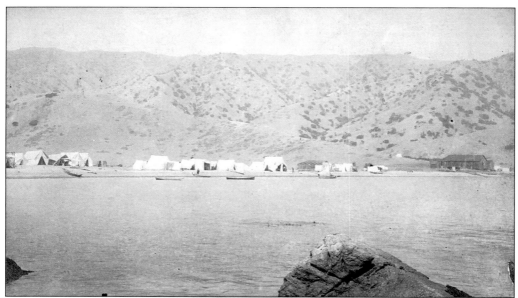

TIMMS' LANDING (AVALON), C. 1879. By the summer of 1883, there were 30 tents and three wooden buildings at Timms' Landing on the island. The island's owner, James Lick, had died in 1876, allegedly as the wealthiest man in California. The Lick Trust continued to manage the island for more than a decade, until Lick's illegitimate son contested the trust, and new trustees sold the island in 1887. (CIM.)

HOWLAND'S LANDING. William Roberto Garcia (1820–1888) stowed away on an American vessel heading out of Portugal. Along the way, he connected with Capt. William Howland, taking his last name. Howland began raising sheep on Santa Catalina Island in about 1857. In 1860, at age 40, he married teenaged Sarah Ann Simmons (1847–1926), and they had seven children: Joseph, William, Charles, Edward, Albert, Grace, and Robert. Their son William was said to be the first American child born on Santa Catalina Island. (SL.)

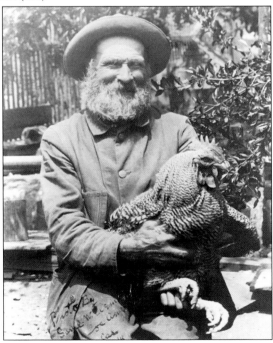

"CHICKEN JOHNNY" BRINKLEY. Not all visitors to Santa Catalina Island were transient pleasure-seekers. John Brinkley (1847–1936), an Englishman from Kent, arrived at Timms' Landing around 1885. He lived as a hermit in his white-washed plank house just outside the growing beach community, raising chayotes and bananas and Plymouth Rock chickens, among other things. He preferred his coal oil lamp over electricity. Chicken Johnny died on June 1, 1936, at age 92. (CIM.)

SHATTO'S SANTA CATALINA ISLAND (FROM 1887 TO 1891). At the age of 37 in 1887, real estate speculator George Rufus Shatto (1850–1893) bought the island from the Lick estate. He was the first to envision development of a resort town at Timms' Landing. Shatto surveyed and mapped, laid out streets, and subdivided and sold lots for $150 to $2,000. People came to pitch tents and build summer cottages. His sister-in-law, Etta Marilla Whitney, changed the name of the bay to Avalon. (SL.)

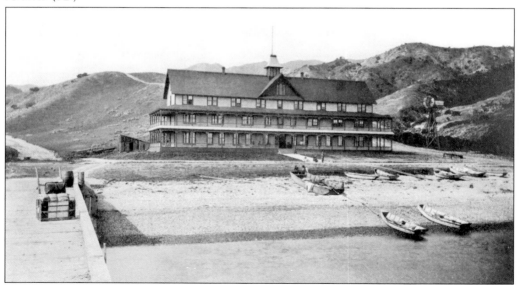

SHATTO'S HOTEL METROPOLE, C. 1887. To enhance his new summer-isle playground, in 1887, George Shatto immediately invested in construction of the magnificent two-story Hotel Metropole, complete with a pier to accommodate steamer traffic. As Shatto's lots sold, businesses, cottages, and tent camps expanded nearby. Massachusetts resident Alonzo Wheeler was one of Shatto's first real estate customers, buying and developing multiple oceanfront lots just south of the Hotel Metropole. (CHS.)

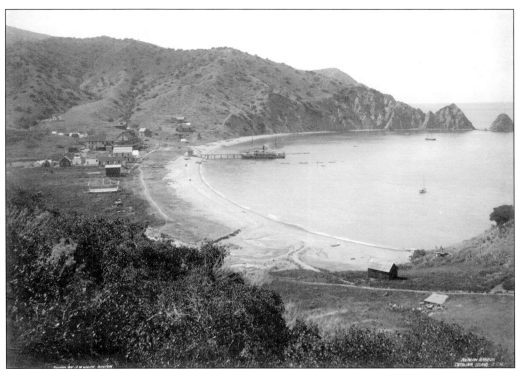

SHATTO'S AVALON, C. 1888. In 1888, Shatto purchased the 140-foot steamer SS *Ferndale* to ferry people between San Pedro Harbor and the pier at his new Hotel Metropole. The SS *Ferndale*, with its 160-horsepower steam engine, kicked off Avalon's 1888 summer camping season. To meet the growing transportation demands, Shatto sought assistance from the Wilmington Transportation Company (WTC), established in 1877 by Phinneas Banning (1830–1885). In 1892 and 1893, WTC handled 36,000 passengers! (CSL.)

ARRIVAL OF THE *FALCON*. Wilmington Transportation Company incorporated in 1884. WTC accommodated cross-channel traffic with 19th-century passenger vessels including the side-wheel steamer *Amelia* (1880–1883), *Warrior* (1883–1900), *Falcon* (1886–1903+), and *Hermosa* (1889–1902). Shatto sold SS *Ferndale* to WTC, and when he defaulted on his island purchase, Phinneas Banning's sons eagerly bought Santa Catalina Island in 1891. (CIM.)

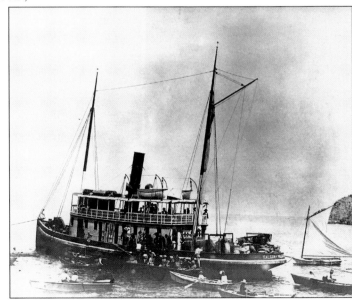

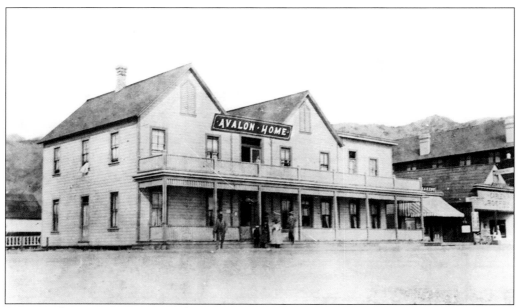

AVALON HOME, 1889. In December 1888, Massachusetts-born Alonzo Wheeler (b. 1836) and his wife, Sophia Atwood (b. 1838), paid Shatto $2,660 for five lots of block 4, where they built their lodging house. Advertisements published in the *Los Angeles Herald* announced: "First-class hotel. Pleasant dining room. Efficient service. Table supplied with the best the market affords." In the summer of 1890, the Wheelers enlarged and improved their hotel. Avalon Home was open year-round, with "fish right out of the water a specialty." (CHS.)

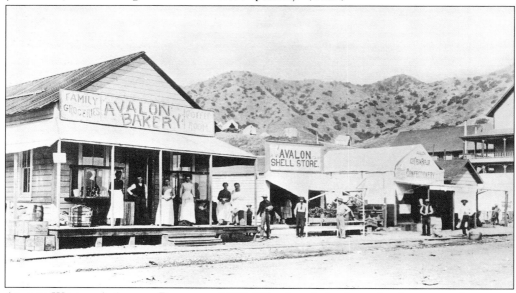

ALONZO WHEELER'S AVALON BAKERY, C. 1892. Wheeler, a baker by trade, also operated a grocery store, bakery, and coffeehouse next to the Avalon Home. "First class home-made bread, pies and cakes. Only the best material used," he advertised. The hardworking Wheeler also owned and operated the schooner *Ruby*. In July 1891, the *Los Angeles Herald* reported: "The Avalon House is a better hotel than the Metropole ever was." (SCICo.)

JEWFISH WEIGHING 342.5 POUNDS CAUGHT ON JULY 30, 1889. Fishing was one of the allures of Santa Catalina Island for both men and women. Many local boatmen offered charter services on yachts and launches before the 20th century, including Mexican Joe's *Catalina* and *Tio Juan*; George Connell's *Mascot*; Capt. Alexander McDonnell's *Fleetwing*; Captain Hayward's *San Diego*; Douglas White's *Ramona*; and *Mildred*, which belonged to Avalon's first postmaster, Harry Elms. (CSL.)

AN HOUR'S CATCH, C. 1896. Next to a skiff on the sand in front of the Hotel Metropole, a cioppino of sea life—three lobsters, nine eels, and more than two dozen fish—is strung along this unidentified young man's oars. In 1898, Charles Frederick Holder (1851–1915), who spent his lifetime awakening the public conscience to the rights of marine life, founded the world-famous Tuna Club. In 1910, Holder published *The Channel Islands of California*. (CSL.)

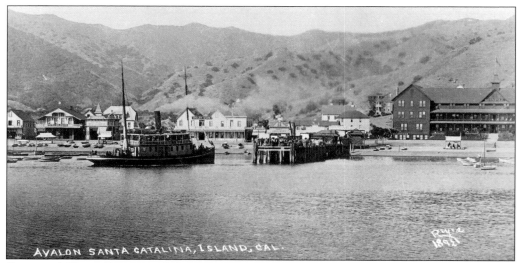

CATALINA'S HOTEL BOOM. With financial difficulties plaguing Shatto, his popular Hotel Metropole closed for the 1891 season. Additional accommodations sprang up to meet pleasure-seekers' demands, including Glenmore, 1891; Crescent, 1892; Catalina, 1892; Grand View, 1892; Miramar, 1892; Sunset, 1892; Sea Beach, 1893; Glidden Flats, c. 1893; Island Villa Hotel, with its 200-summer-tent-cottage annex, 1895; Stamford House, c. 1895; Pasadena Hotel, c. 1895; Marilla, 1896; and Bay View, c. 1898. By 1900, over 5,000 people were spending summers on Santa Catalina Island. (CIM.)

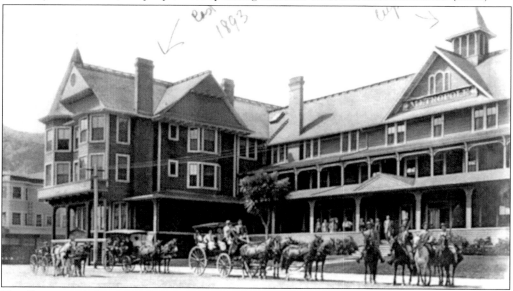

THE BANNINGS' CATALINA (FROM 1891 TO 1919). In 1891, the Lick Trust foreclosed on Shatto, and the island was sold to the Banning brothers, William, Joseph, and Hancock. By 1900, they had constructed the dance pavilion, bathhouse, and country club golf course (built in 1892), Little Harbor Inn (built in 1894), Eagle's Nest Lodge (built in 1896), and Aquarium (built in 1899). To Shatto's Hotel Metropole they added a cupola (1892), east wing (1893), west wing (1896), and ballroom annex (1897). After almost three decades of improvements, the Bannings sold both Santa Catalina Island Company and Wilmington Transportation Company to William Wrigley Jr. in 1919. (CHS.)

Eight

UNDER COMMAND
SAN CLEMENTE ISLAND

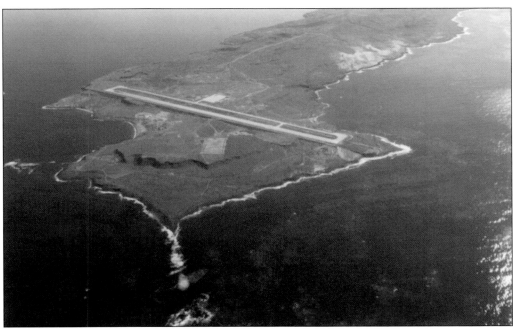

SAN CLEMENTE ISLAND LOOKING SOUTH. San Clemente Island is the southernmost of the eight California Channel Islands and ranks fourth largest in size. It is 56 square miles in area, 21 miles long, and from two to four miles wide. The island is 41 miles offshore—the second farthest from the mainland. Santa Catalina Island is 21 miles to the north. Mount Thirst, at 1,965 feet in elevation, is the island's highest point. San Clemente Island is in Los Angeles County and is one of three Navy-owned islands among the California Channel Islands. The other two are San Nicolas Island and San Miguel Island (the latter is administered as part of Channel Islands National Park). Two offshore rocks on the north end are named Bird Rock and Castle Rock. (US Navy.)

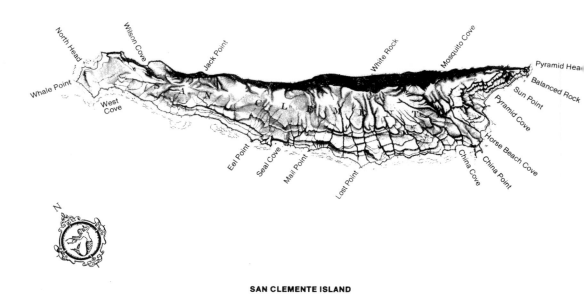

SAN CLEMENTE ISLAND

SAN CLEMENTE ISLAND. San Clemente Island became US government property when California became a state in 1850. The island served as a transient home for sportsmen, and ranchers moved onto the island in the 19th century, introducing livestock. From 1901 to 1934, the government leased San Clemente Island to private sheep-ranching interests. Native terrestrial mammals are limited to the island fox and island deer mouse. (SCIF.)

SOUTHEAST END OF SAN CLEMENTE ISLAND, 1856. In 1854, by order of Pres. Franklin Pierce, San Clemente was reserved for lighthouse purposes. Although there is no lighthouse on the island, there are several navigational lights. The US Coast and Geodetic Survey worked on the island in the early 1860s. An 1874 survey of the island reported four good harbors or landing places: North Harbor, Shubrick Harbor (Wilson Cove), Mosquito Harbor, and Smugglers Cove (Pyramid Cove). (SCIF.)

CANYON, SOUTH PART SAN CLEMENTE ISLAND, CALIFORNIA, BY JAMES MADISON ALDEN, JUNE 1856. US Coast Survey artist James Madison Alden (1834–1921) painted this first known view of San Clemente Island. This canyon is close to Mosquito Harbor, about 14 miles southeast of Wilson's Cove on the eastern shore. It is one of the few coves on the island with fresh water, and it offers shelter for boats during the summer months. (BRBML.)

ALBERT SHADE, SAN CLEMENTE ISLAND, 1908. For more than 15 years, from 1899 to around 1916, German immigrant Albert Shade (b. 1868) lived part-time in his sportsmen's camp at Mosquito Harbor on the southeastern part of the island. Shade, also a resident of Avalon on Santa Catalina Island, offered fishing and camping trips with his launch, *Pilgrim*, as well as Indian relic hunting. He moved to Mosquito Harbor after Alex O'Leary vacated his residence there. (SCIF.)

SPORTSMEN, 1909. Al Shade counted celebrities among his many clients, including authors Zane Grey and Stewart Edward White, the Bannings (of Santa Catalina Island), and Gen. George S. Patton Jr. In September 1909, zoologist Charles Frederick Holder (left) accompanied Gifford Pinchot, superintendent of the Forestry Division of the Agricultural Department (center), and former California governor George Pardee (right) to the island. Pinchot is holding a bald eagle shot on their trip. (SBHM.)

WILSON'S COVE, SAN CLEMENTE WOOL COMPANY, (FROM 1892 TO 1918). The San Clemente Wool Company was incorporated in 1892 by Judge Stephen Hubbell of Los Angeles with a capital stock of $50,000. Other investors included Charles Hubbell of Compton; Santa Catalina Island sheep rancher Frank Whittley and his wife, Lucy; and Oscar Macy of Los Angeles. After more than a decade of sheep operations on the island, the company received its first government lease, from 1901 to 1905, and renewed it from 1906 to 1909 and 1910 to 1918. (SCIF.)

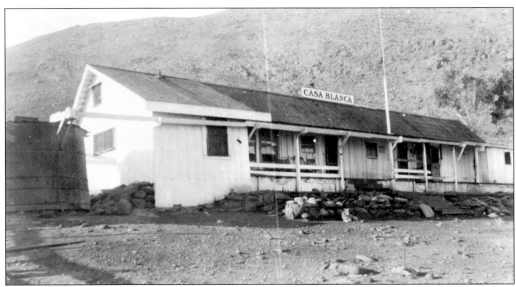

CASA BLANCA, WILSON'S COVE. The San Clemente Wool Company developed extensive ranch headquarters at Wilson's Cove, formerly known as Gallagher's. It built the 65-foot-long, eight-room Casa Blanca; a 40-foot bunk house; wool sheds; shearing pens and sheds; corrals; a blacksmith shop; a barn; and a small wharf. Tanks were used to catch rainwater from roofs. Additional outposts were constructed at the island's north end—Ocean Spring, Red Canyon (Chinetti's), and Russells. (SCIF.)

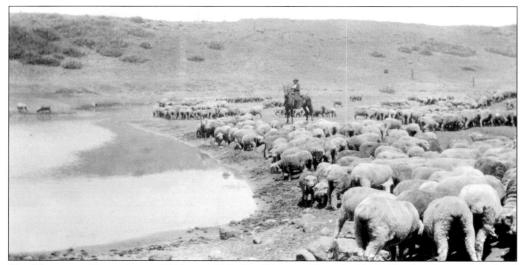

THE HOWLAND YEARS (FROM 1903 TO 1916), BIG HOLLOW DAM. In 1903, Charles Taggart Howland (1868–1938), the third son of Santa Catalina Island sheep rancher William Howland, purchased the San Clemente Wool Company along with other investors, including his mother, Sarah Howland (who served as treasurer); his youngest brother, Robert Howland (vice president); and his friend A.C. Harper (president). Charles Howland served as company secretary and manager. At great expense, Howland dammed canyons and developed the island's water system. (SCIF.)

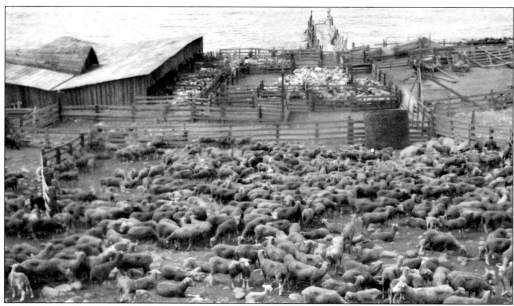

SAN CLEMENTE SHEEP COMPANY (FROM 1916 TO 1934), WILSON COVE. The San Clemente Sheep Company was incorporated in 1916 by Montana ranching partners Lewis Penwell and E.G. Blair for the express purpose of buying the San Clemente Wool Company and its assets from Charles Howland. Blair was the company's largest stockholder, president, and manager. In 1918, the government lease was successfully reassigned to the San Clemente Sheep Company. (SCIF.)

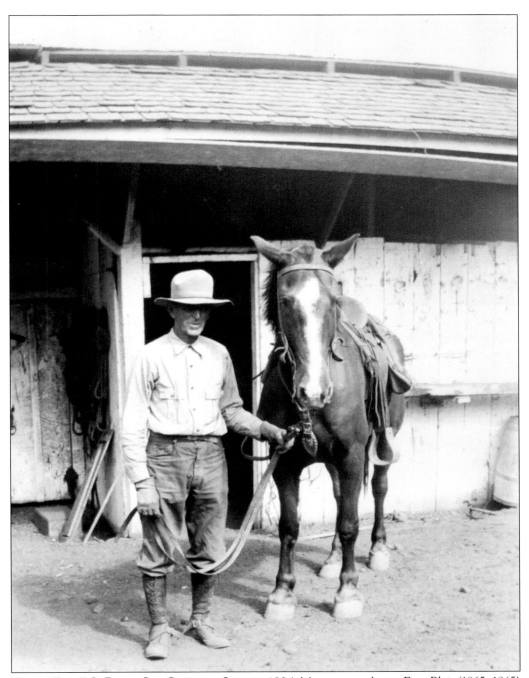

ERVIN "ERVE" G. BLAIR, SAN CLEMENTE ISLAND, 1934. Montana stockman Erve Blair (1865–1965) moved to Southern California in 1913 with his wife, Russie, and their three children, Erwin, Marion, and Roscoe. As managing partner of the San Clemente Wool Company, Blair raised sheep and exported wool from the island for the next 16 years. In 1934, the government lease was cancelled, and by executive order, the island passed from jurisdiction of the Secretary of Commerce to control by the Secretary of the Navy. (SCIF.)

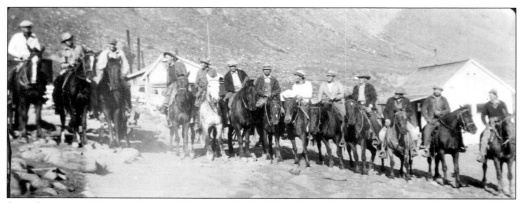

SAN CLEMENTE ISLAND RANGE RIDERS, 1933. When Erve Blair and the San Clemente Wool Company took over the lease of San Clemente Island, the assets were said to include "25,000 head of sheep, blooded stallions, draft mares, colts, jacks, and mules." The island was regarded as an ideal location for a big sheep ranch in close proximity to Los Angeles, "the greatest lamb market in the world." (SCIF.)

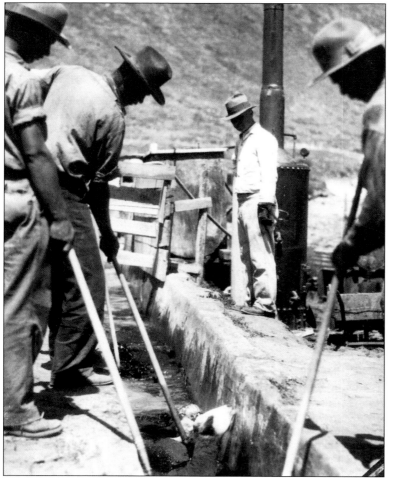

SHEEPMEN ON SAN CLEMENTE ISLAND, 1933. Sheep had little human contact until the annual shearing time in May and June. During World War I, each sheep produced a little more than enough wool for one uniform. Scabies persisted on the island in the 1930s, and a crew of riders was employed to assist in the eradication efforts. New holding pastures were built, and sheep were forced into dipping vats. (SCIF.)

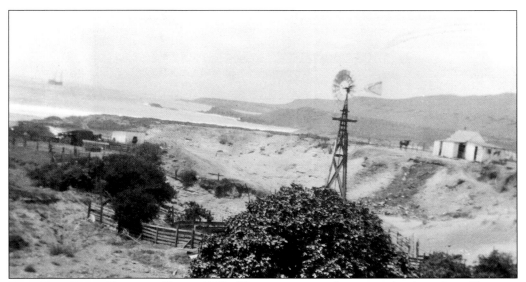

EAST END CAMP, PYRAMID COVE, 1933. This outpost was home to island resident Chinetti, who died here in about 1919. According to Buster Hyder, who found his body: "He looked like he might be half Spanish or maybe half Mexican. He was a guy about five-foot-ten—a very jolly sort of fellow. He went to work for Mr. Blair as a watchman on the east end to keep the fishermen off." (SCIF.)

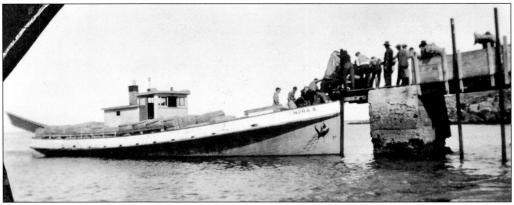

NORA II LOADED WITH WOOL SACKS, SAN CLEMENTE ISLAND, 1933. Between 1918 and 1934, Al Hyder's boat, *Nora II*, was used by the San Clemente Sheep Company to haul sheep and wool sacks from the island to Long Beach. After the six-hour trip, the sheep were loaded into trucks and distributed to Los Angeles markets. (SCIF.)

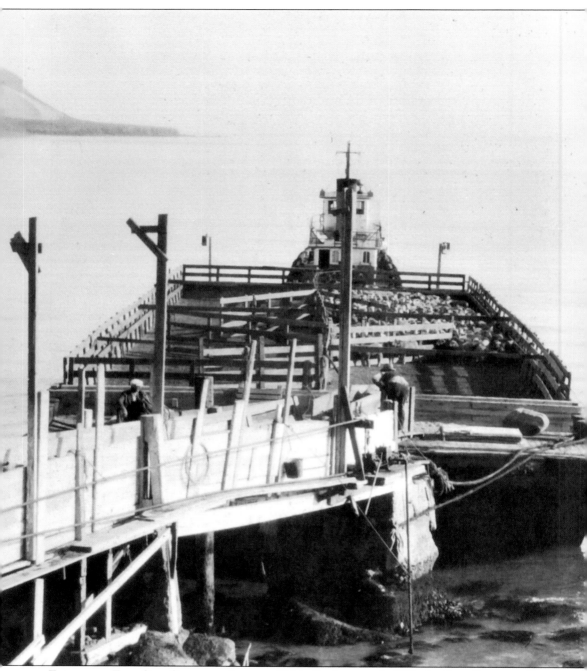

END OF AN ERA, SAN CLEMENTE ISLAND, 1934. On January 5, 1933, the San Clemente Sheep Company granted the US Navy permission to establish, maintain, and use an emergency landing field on the island. The following year, in 1934, the government cancelled the sheep company's lease, sheep operations ended, and the Navy's administration of the island began. Thousands of sheep were shipped off the island by tug and barge. (SCIF.)

WILSON COVE, 1936. San Clemente Island has been owned and operated by various naval commands since 1934, the year the Army, Navy, and Marine Corps began conducting fleet battle group tactical and amphibious exercises. In 1935, civilian workmen began construction of a fighter-aircraft training base, which included a pier, roads, an airfield, and 13 major facilities—including headquarters, a fire station, a galley/mess hall, personnel barracks, and utility support structures. Target ranges and concrete bunkers soon followed. (US Navy.)

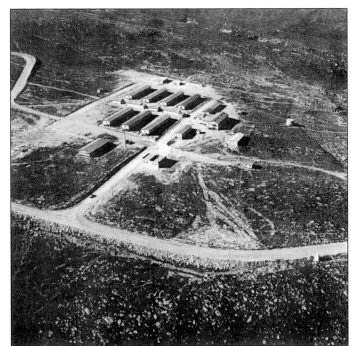

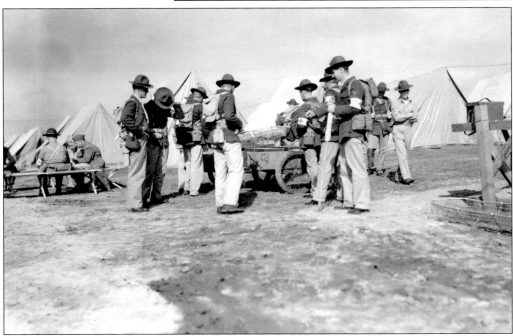

MARINE CORPS FIELD HOSPITAL TRAINING, 1936. In 1937, Pres. Franklin D. Roosevelt designated the area of water surrounding San Clemente Island as a sea area for national defense. The island's military operations escalated as World War II approached, and the naval air station was fully operational by 1941. The Shore Bombardment Area (SHOBA) was established on the southern third of the island in 1942 for offshore and aerial bombing and target practice. (US Navy.)

SHOBA UNEXPLODED ORDNANCE, SAN CLEMENTE ISLAND, **1986.** More than a dozen range and operational areas are clustered within a 60-mile radius of the island. Between 1935 and 2000, more than 250 structures have been built on the island. In the 1950s, the island was redesignated as an Outlying Landing Field (OLF) to Naval Air Station San Diego (now Naval Base Coronado), which continues to be responsible for the island's administration. (SCIF, photograph by Marla Daily.)

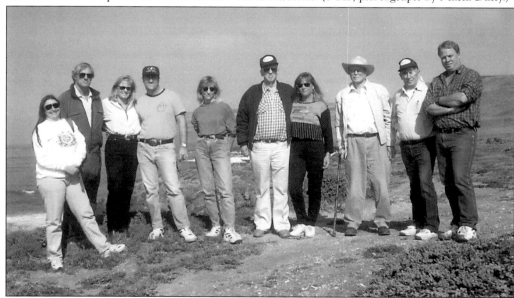

ISLAND NEIGHBORS VISITING SAN CLEMENTE ISLAND, **1997.** San Clemente Island is closed to the public, although limited scientific access and special projects may be permitted. The Santa Cruz Island Foundation organized a trip for neighboring islanders and island-related guests. Pictured here are, from left to right, Marla Daily, Mark Connally, Nita Vail, Bill Everett, Lauretta Lowell, Al Vail, Mary Vail, Clif Smith, Russ Vail, and Tim Vail. (SCIF.)

BURGEE OF THE ALL EIGHT CLUB, ESTABLISHED IN 1994. The flag's eight white stars, set in two groups, represent the four Northern and four Southern California Channel Islands. The All Eight Club was established in 1994 by the Santa Cruz Island Foundation to identify and honor those who have visited all eight California Channel Islands. To qualify, one must have walked on San Miguel, Santa Rosa, Santa Cruz, Anacapa, Santa Barbara, Santa Catalina, San Nicolas, and San Clemente Islands. Access to San Nicolas and San Clemente Islands is difficult to obtain due to their active military status. Members of the All Eight Club include biologists, anthropologists, botanists, ornithologists, zoologists, educators, helicopter and fixed-wing pilots, a retired national park superintendent and park employees, a museum director, a lichenologist, a photographer, a retired judge, and a sea captain. This is said to be the most exclusive recognized geographic club in the world, with membership in the low 100s—a 10th the size of the famous 7 Summits Club. (SCIF.)

Discover Thousands of Local History Books
Featuring Millions of Vintage Images

Arcadia Publishing, the leading local history publisher in the United States, is committed to making history accessible and meaningful through publishing books that celebrate and preserve the heritage of America's people and places.

Find more books like this at
www.arcadiapublishing.com

Search for your hometown history, your old stomping grounds, and even your favorite sports team.